AQUARIUM

The most beautiful experience we can have is the mysterious.

It is the fundamental emotion which stands at the cradle of true art and true science.

Whoever does not know it can no longer wonder, no longer marvel, is as good as dead, and his eyes are dimmed.

–Albert Einstein

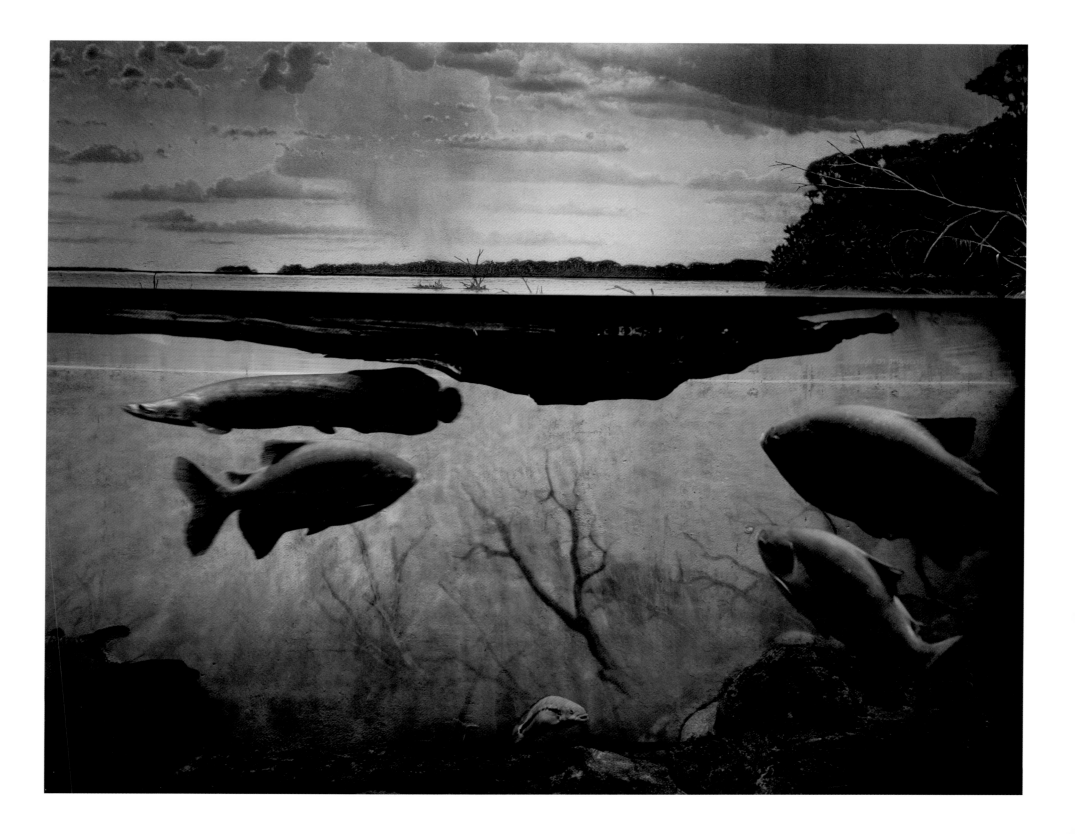

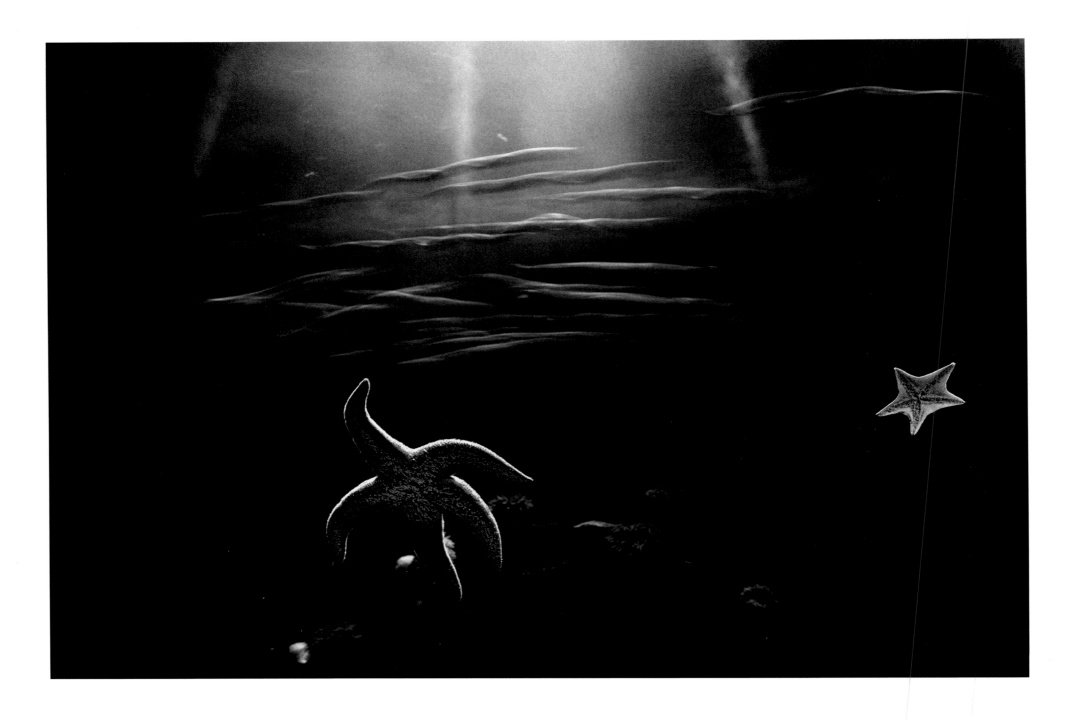

AQUARIUM

BLACK-AND-WHITE PHOTOGRAPHS BY DIANE COOK

COLOR PHOTOGRAPHS BY LEN JENSHEL

ESSAY BY TODD NEWBERRY
INTERVIEW BY LAWRENCE WESCHLER

APERTURE

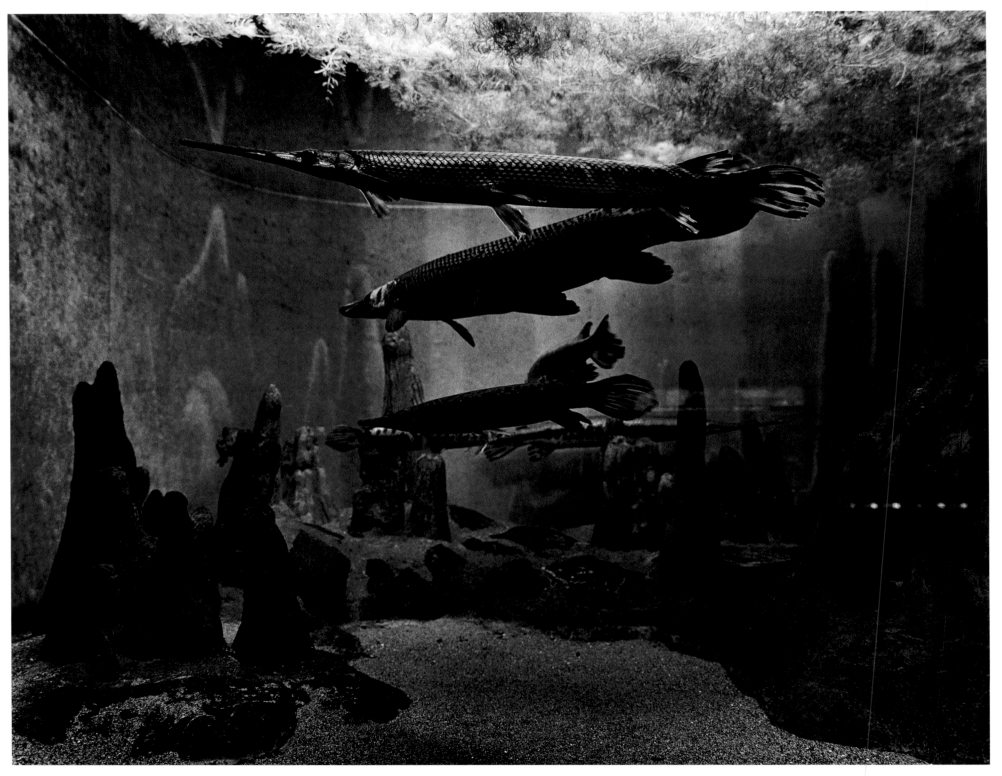

A VISIT TO THE AQUARIUM

TODD NEWBERRY

The animals in a zoo share our terrestrial world. They breathe the same air that we do. They may smell the wind more acutely and have other abilities we lack in full measure, but they and we alike face the seasons, the daily weather, the wind and sun, the drag of gravity when we are tired. The zoo's mammals (and let's acknowledge it, mammals and some birds are the point of zoos) are furrier than we are, but only by degrees. Many of them – probably all the ones that make us stop and look – share keen vision with us. Standing before their pens and cages, we cannot help but regret their captivity as we would regret our own: look into their eyes.

Even at a large zoo, where the big animals can roam over a disguised pasture or an ersatz island, we sense their exile. I can hear the traffic and see the skyscrapers, and so can they: it's a park in New York, not a savanna in Kenya. The best zoos are country-club prisons. On what charges are we holding their inmates? A day at the zoo fascinates me, but I go home downhearted. The next day, I seek out wild animals.

But those are zoos. Aquariums are different. Aquariums are where we confront scaly swimmers, animals without backbones, animals whose heads don't turn, creatures without faces. Aquariums have animals that never touch the ground and others that settle to the ground and never move again. They have animals that look like plants or stones or the water itself. Strange appearances are signs of strange lives. Land animals, so familiar to us, encase themselves with fur, feathers and waxy cuticles. They depend for their lives on elaborate armor,

both anatomical and physiological, against the land's harsh conditions. Most sea animals – the stock in trade of aquariums – can open themselves in harmony with truly another world.

Many fishes are strange enough, but to feel how different life in the sea is, look instead at marine invertebrates. See how many of them have structures that would collapse under their own weight in the air, but instead spread buoyantly through the supporting water. Many of them extend feathery tentacles and gills like fronds, others use mucous nets to strain food that floats by; still others pass copious amounts of water through their inflated bodies to filter it for food. Their physiology is as different from that of fish as their anatomy is, and so are their ways of perceiving their world. Invertebrates make fish seem almost like one of us.

The sea is not just "the blue continent," it is the blue planet. For all the ways our ocean of gaseous air is like the ocean of liquid water – both air and water are fluids, downwind is downstream, jet streams are great currents – as a place to live, air is not at all like water. Even animals with good eyes see only yards, not miles, underwater. The sea is a world for the nearsighted. And, for the most part, it is a world where any vision at all helps only near the surface, above the darkness that prevails at depth, broken there only by flickering bioluminescence. But unlike light, sounds, especially low ones, go vast distances in the sea; sperm whales hundreds of miles apart can listen to each other. And the sounds in the sea

are not just whales' songs. They are a cacophony of invertebrate and fishy squawks and clicks, murmurs and whistles and sighs.

Not only is the sea noisy, it is a broth of chemical information, too. Sea animals do not just sniff the current as deer check the breeze. They depend on their habitats' tastes and dissolved smells to guide them through their lives. On land and in the sea alike, animals pour forth odors; but in the water these scents waft and spread slowly and linger in pools and gradients of intensity, full of meaning about food and sex and where to live and when to hide.

At the zoo, I feel an affinity with the captives, as though we spoke the same warm-blooded language. Even at the aquarium, some of the creatures live in my world – the sea lions and penguins and even the turtles, with their lungs instead of gills, and their flippers and wings instead of fins, and their sad eyes. And so they seem to me dreadfully out of place there, as though someone's pets had gotten trapped on the wrong side of the glass.

But how can I feel affinity with fishes, medusae, and sea stars? I see them well, but they see me only dimly or not at all. And the glass between us keeps me from any possibility of detecting… detecting I know not what. Do they even know they are trapped? Do they care? I am sure the porpoise does, as much as the zoo's tiger, and I am beginning to think the great sharks must, too. But as for the rest? So, at the aquarium, with an occasional furtive glance over my shoulder at the inmates that bother my conscience, I settle down eventually with the animals that don't – or don't yet. These are tentative acquaintances.

As the photographs in this book show me, many visitors to aquariums find themselves as engrossed and perplexed as I do by the experience. At the most fundamental level, here are discordant worlds. Humanity gazes awkwardly at captured nature. But it isn't nature anymore; it's a show window. The more we try to pretend that we are looking through a porthole in Captain Nemo's submarine, the more we come up against the constructed setting.

The aquarium experience is more complicated than just a standoff. Even in front of the stupendous, multistory tanks of, say, the Monterey Bay Aquarium, I feel what I feel in art museums when I see rows of paintings that were meant to hang by themselves on their own walls. Each of those paintings once made full claim on its viewer's contemplation, but now there is too much going on in too little space. So also in aquariums, even in those that try to show not only the animals but also the larger world of the sea itself: the ecology is compressed. I find myself staring at many exhibits with curiosity – a confined attention – rather than in wonder, which needs plenty of room.

When the exhibits let us, we aquarium-goers can break free of this sense of confinement by so focusing our attention, so drawing ourselves to the animals themselves, that the

exhibits' walls seem to recede. Focusing does this, as when we draw close to a friend in conversation, and our surroundings melt into the background. True enough, at the aquarium, separated by glass, we can do little more than look at the animals. We perceive them solely on our visual terms, and probably not on theirs, whatever theirs even may be. For me, this sensory exclusion from their lives is what most separates me from those animals in the tanks. We meet (or, rather, pass) as creatures from worlds apart: not a promising start to a friendly conversation. And yet, this very disconnect surely adds to the sense of strange encounters that prevails in a great aquarium.

Even so, here is a way to start to draw closer: we can ask the animals about what I will call simply their appearance. Animals lead social lives that involve communicating needs and intentions. The sexual and territorial displays of birds and mammals are cases in point. Many fishes lead complex social lives too, and to the extent that they form images with their eyes they convey and receive intentions with body language. We can see this in the stickleback's dance, the dragonet's rapturous courtship. Among animals that can see images, many have what the biologist Adolph Portmann called optical organs. These are structures like the elk's antlers, patterns like male birds' plumages, that make most sense as ones that are meant to be gazed upon, with due effect, by others of the owner's kind, potential mates or rivals – advertisement organs, another behavioral biologist has called them. Think again of the stickleback, but look at its red belly; think of the dragonet again but notice its erectile spines; watch the octopus change its hues.

Sometimes, however, what would seem to be optical organs must be nothing of the sort. For example, those spectacular snails, the nudibranchs, cannot form visual images with their meager eyes; none has ever admired another's beauty that way. Who, then, is supposed to gaze upon their gorgeous colors and patterns, if the nudibranchs themselves cannot? Maybe their plumes, which are actually gut out-pouchings, advertise nasty intestinal tastes and so warn away close-range visual hunters like fish, the way some brightly colored insects warn away birds.

Sound and scent have social roles, too. Think, from our own world, of perfume and whispers, the dog's markings, the bull's bellow, and the cock's crow. They are invisible appearances. While we may see the behavior they induce among the other animals in the tank, at an aquarium, these communications themselves are hidden from us behind that thick glass. We know that many marine creatures, such as fish, snapping shrimp and the celebrated whales, make a lot of noise and hear well – to what purposes? And we know that almost all underwater vertebrates and invertebrates, including the very simplest, are keenly sensitive to the chemicals around them. Surely they have exploited these senses to communicate with each other, too. With enough receptors, can some underwater animals even make "images" of these perceptions, the way we do of visual ones? The aquarium's little tanks off in the corner – the ones that hold those invertebrates that are "doing nothing," rather than the big ones with the crowd-stopping fishes – are where I go to try to catch these invisible signals and responses among the animals there.

Animal appearances also include disappearances: camouflage. Animals hide from enemies that hunt by sight, and in the sea many of them, swimming in open water, have to hide in plain sight from their predators. Medusae, comb jellies, and many other drifting forms camouflage themselves by their glassy transparency. Open-water fishes may shade themselves the way warships once did, breaking up their bodies with patterns of light and dark that confuse searchers. Or they may become silvery mirrors that sparkle momentarily as they catch the sun, then reflect only the open water around them. On the sea bottom, sedentary prey fool their visual predators like fish by imitating algae, stones, and sand. Camouflage serves as such an abundant and diverse ruse that we pass by many camouflaged creatures even in the aquarium tanks, unseen because they have fooled us, too.

Since so many marine predators have poor vision but hunt by smell and taste, surely many bottom-dwelling animals camouflage themselves chemically. It is too good an opportunity for evolution to pass up. Here is an almost unapproachable puzzle. Chemical camouflage must involve one creature smelling confusingly like another, the way visual camouflage imitates misleading optical patterns. But with our own poor powers, how can we ourselves tell that the scent of one species imitates that of another – and then how can we know that we are as puzzled as, say, a roaming sea star?

As a marine biologist, I try not to make a visit to the aquarium just a busman's holiday. Sometimes I do try to compare the ways a half-dozen different kinds of fish swim; some-times I try to relate their jaws to their diets. But for the most part I put aside the exercise of "observing" and try instead merely to lean forward and look closely, paying attention. I try to do that with questions in mind, and ones that can be answered in an afternoon. Many good questions lead only to frustration, because their answers are too huge to fit into the occasion (such as questions about evolution) or too subtle (ones about other creatures' perspectives, which now we know the aquarium abounds with).

When we pare our questions to ones we can answer promptly, we end up with very few. We can describe an animal's appearance, for example, but in the few hours of a visit, we cannot do more than speculate about how that animal might have evolved. Unless we see an appearance "in action," perhaps in the act of courtship or camouflage, we cannot even be sure that we have guessed right about what it does here and now. We can map the distribution of animals in the tank – do they tend toward the surface or the bottom, gather in the shadows or in the open, group together or stay solitary, change neighbors often or persist in their companions? We can describe an animal's behavior and make a few stabs at "what is going on," but in an afternoon, that is about it. Satisfying the rest of our curiosity requires other venues and experiences than aquarium ones. So at the aquarium, I skip the speculation, put aside that word "maybe," and try just to notice what is going on. I am not after a great discovery; I am after a pleasant afternoon.

Most aquarium-goers are not there for the fun of explaining things. They are there for enter-

tainment and an encounter with the strange. I can ask my little questions on my own. Some aquariums play to the thrill-seekers. Shadowed halls lead to strange or even grotesque scenes. Occasionally, perhaps unsure that nature can do the job by itself, aquariums try to emphasize their creatures' beauty with elaborate settings. Usually these efforts boomerang; gardens apart, it is hard to improve on nature. Instead, we can open ourselves to the sheer beauty of the sea's creatures. Then encounters with loveliness, even more than with strangeness, will shape our day.

The mesmerizing beauty of fishes and medusae resides not so much or so often in their bodies, I think, as in their motion, and especially in their motion together. It is motion that transforms all. Almost despite their bodies, these creatures become, exquisitely, the dancer's never-ending leap. My inquiry gives way to astonishment, pure and simple: wonder, after all.

Asking questions, looking at appearances, simply noticing what is going on, watching animals move – these ways of honoring an aquarium's creatures can make it a place not just of amusement but of revelation. And this experience will thwart a numbing habit we all fall into now and then, of moving along too fast – what I call "glance and go." Here is an analogy. In art museums, I move along too fast if I try to look at too many paintings. My wife, a curator, has told me that she looks at a painting until it speaks to her, as the good ones will. That takes patience; it adds up to very few paintings in a day. But because there is so much there to see, many gallery-goers (or aquarium-goers) move along so fast, that a painting (or a fish) doesn't even have the chance to clear its throat before its visitor is gone.

If I remember right, in London during World War II, a cautious National Gallery exhibited in rotation only one great painting at a time. Visitors told of seeing those works as they had never seen them before. They could not glance and go. They had to stop and really look awhile. The painting had a chance to speak. Fish are not Vermeers, but maybe an aquarium could try this. If need be in a special section of its own, it could mount just one exhibit to catch and hold a visitor's attention. We could ask the animals questions that would take them a little while to answer. Then we would wait for them to speak.

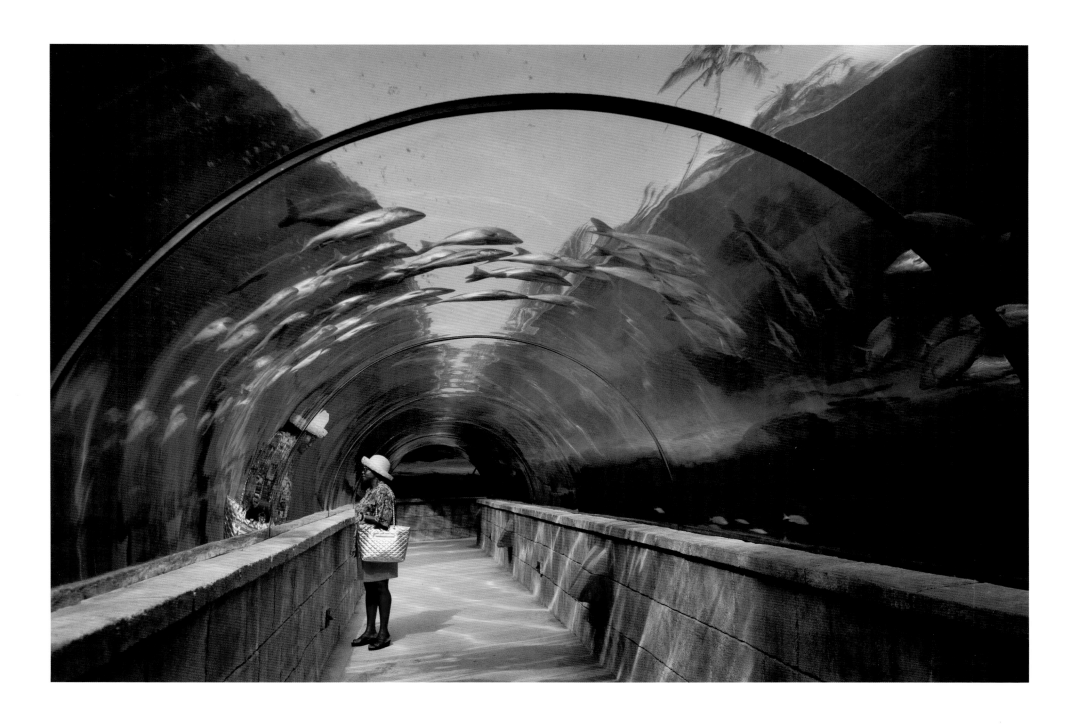

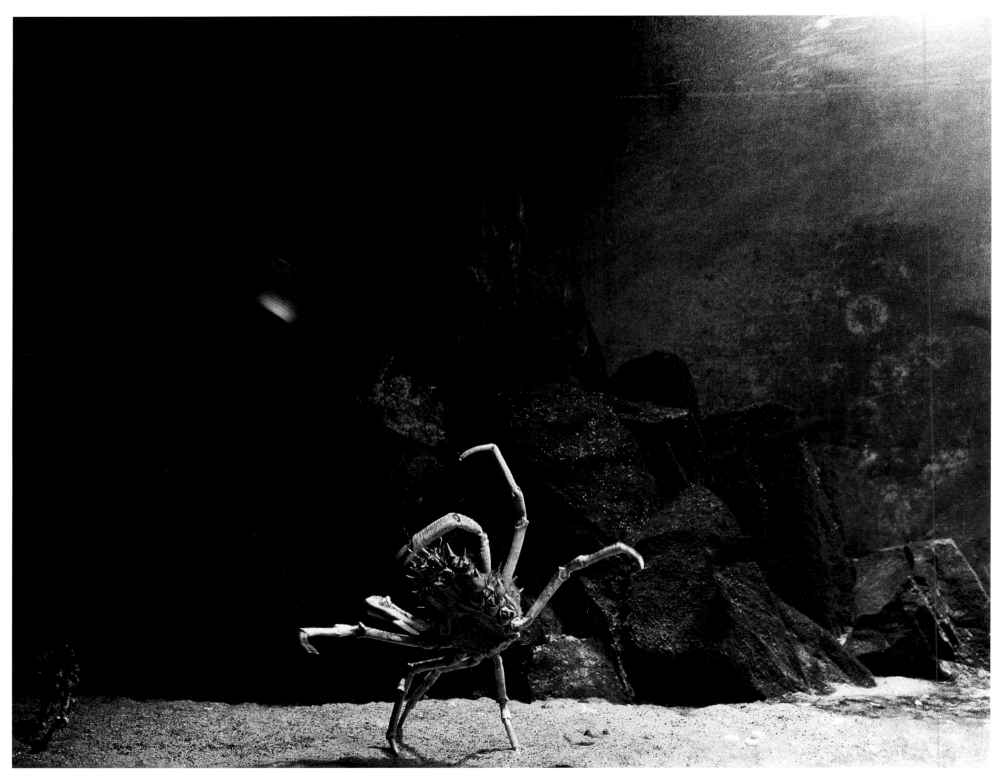

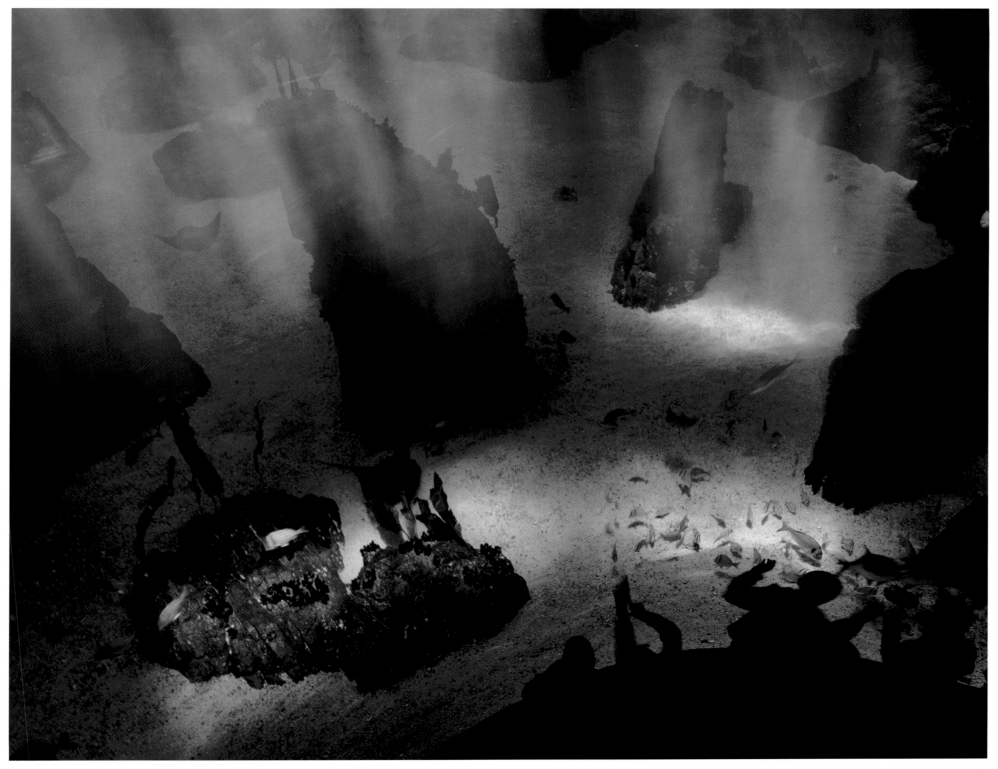

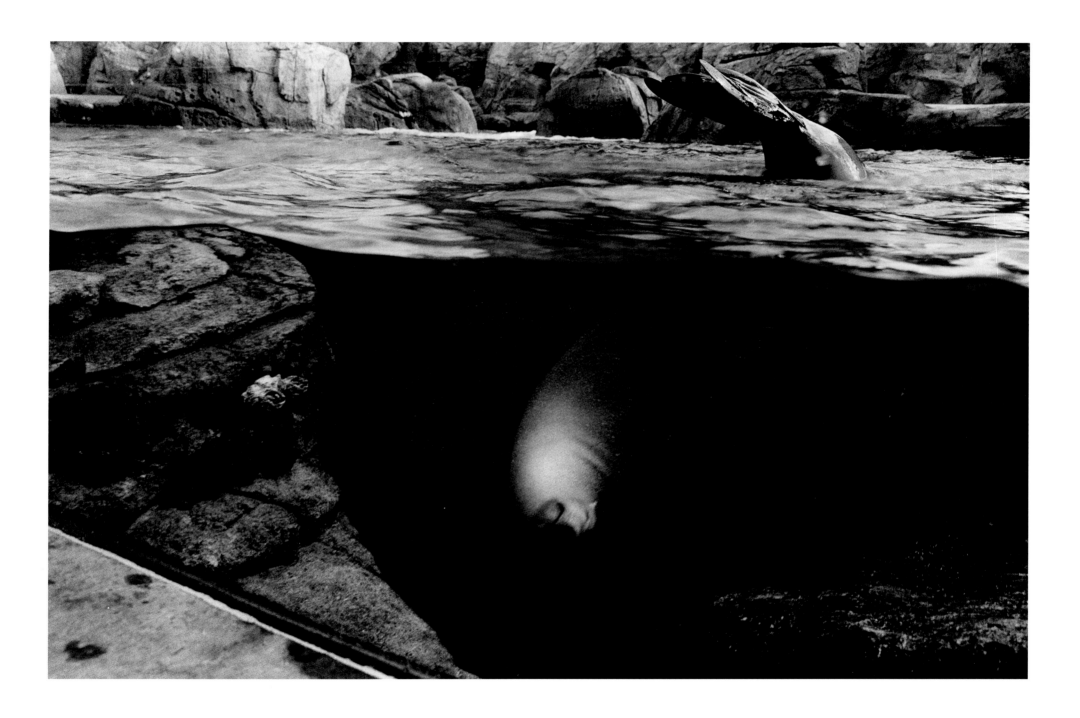

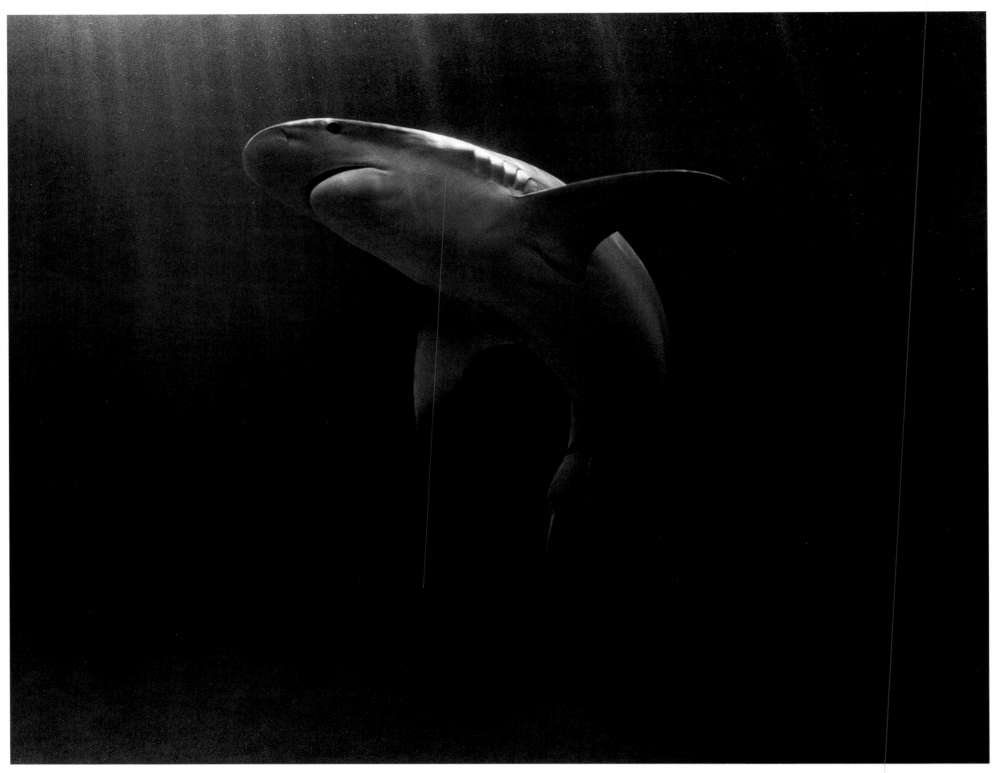

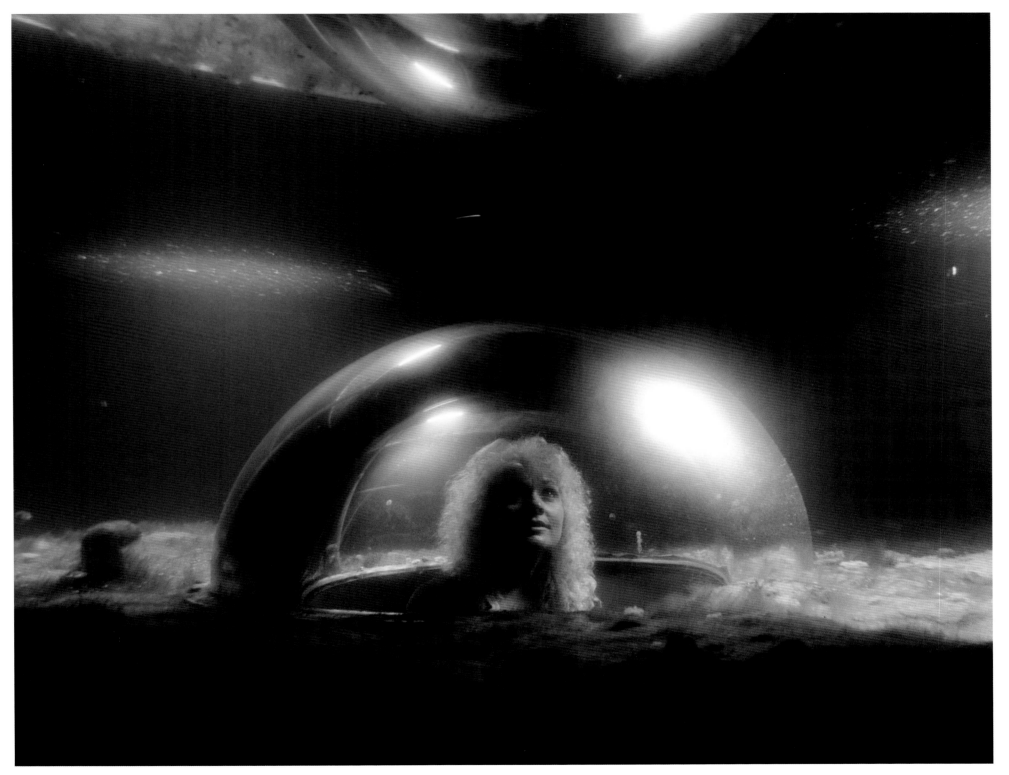

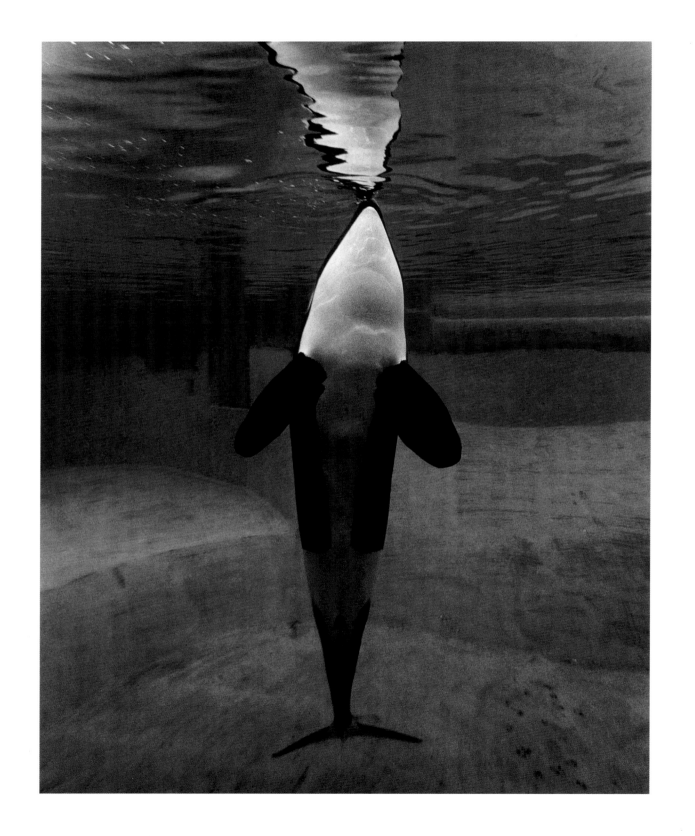

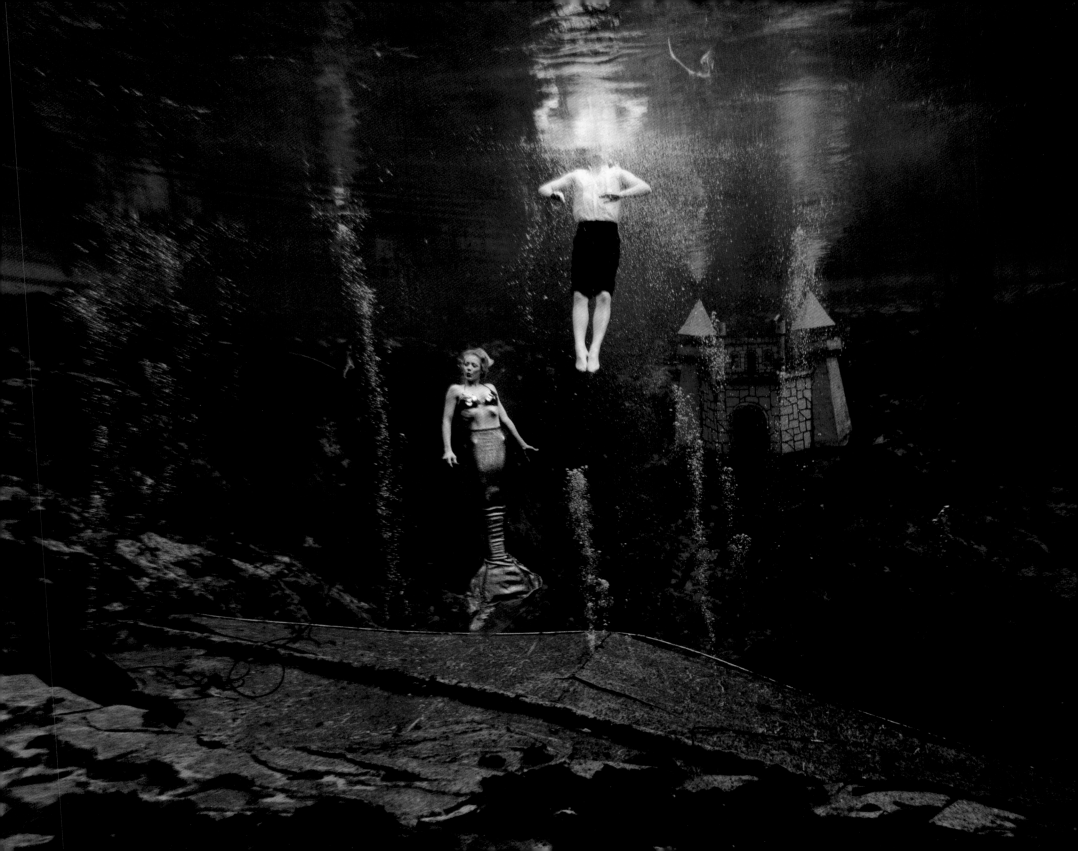

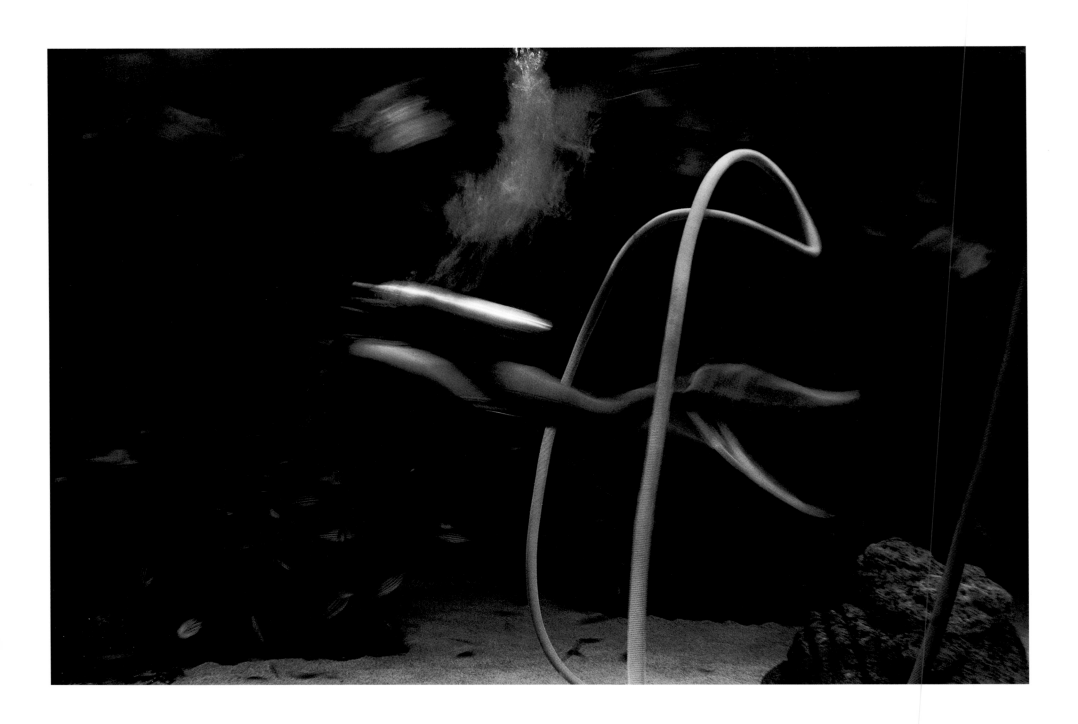

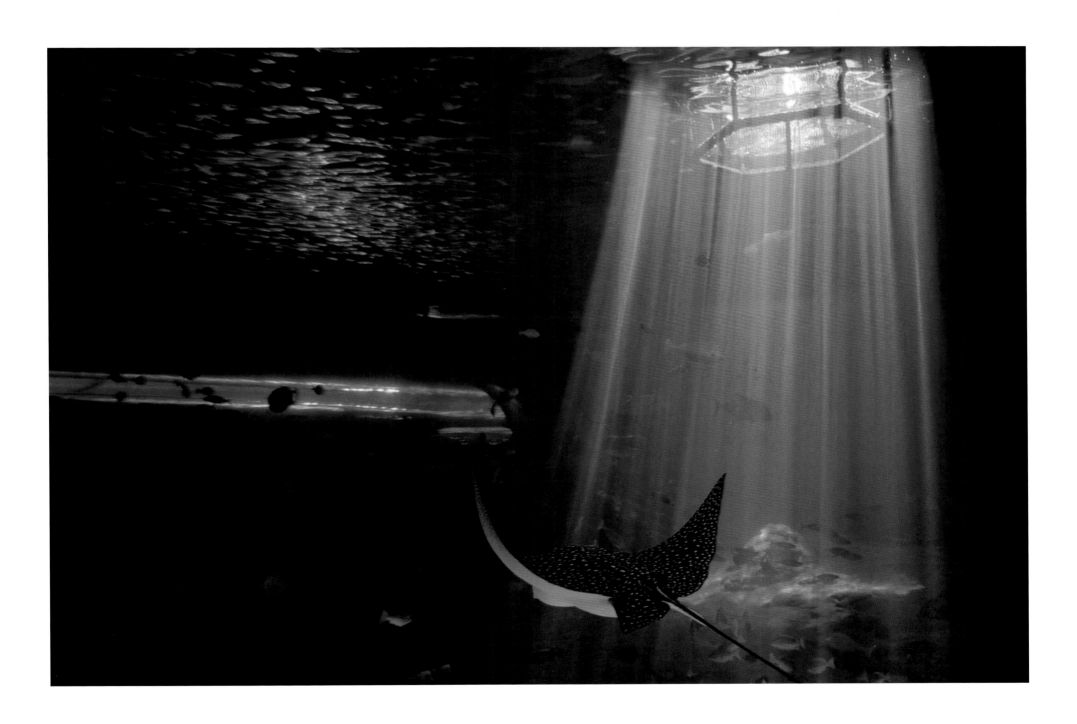

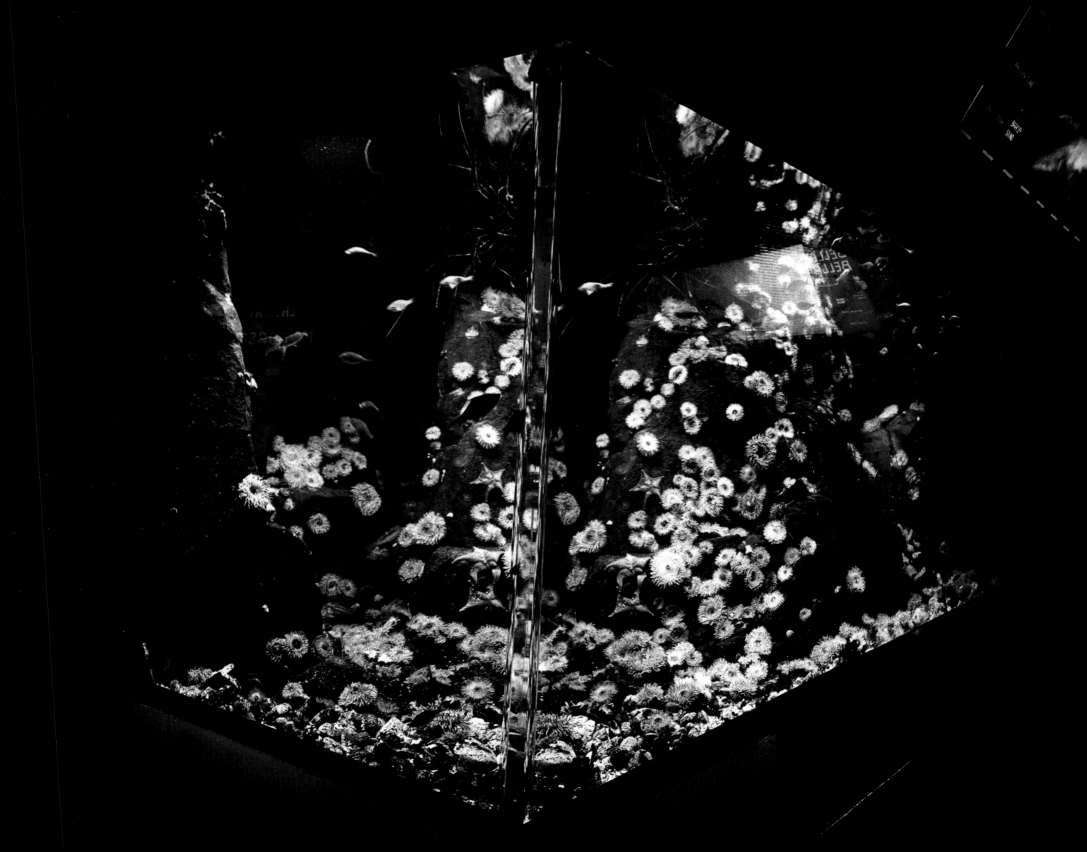

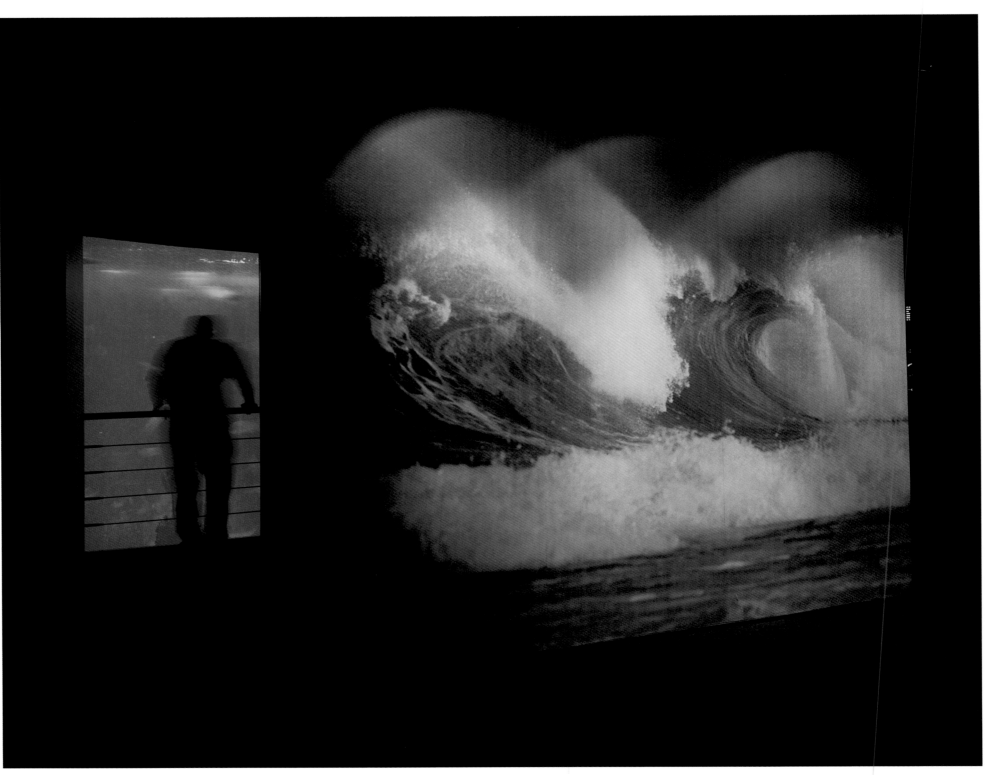

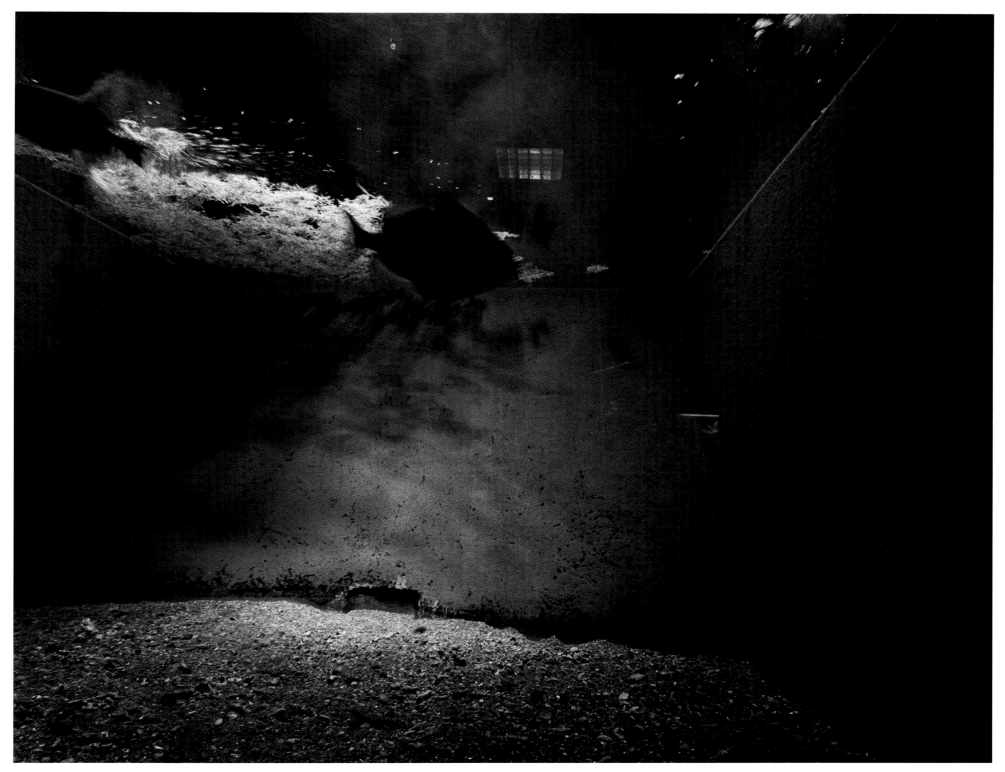

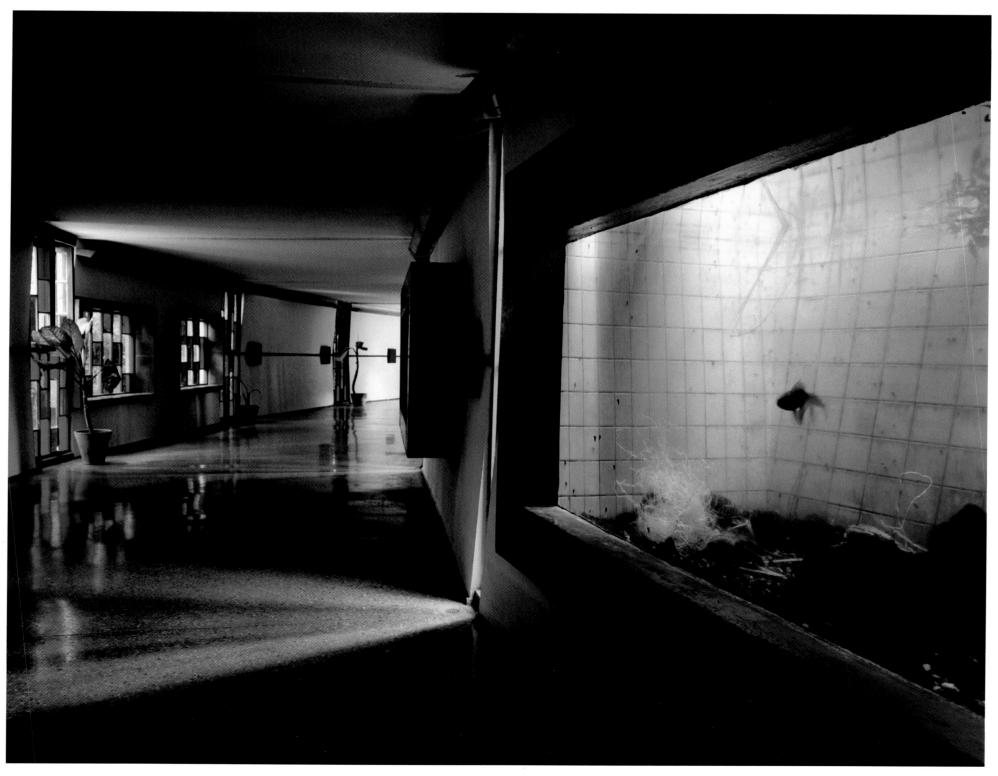

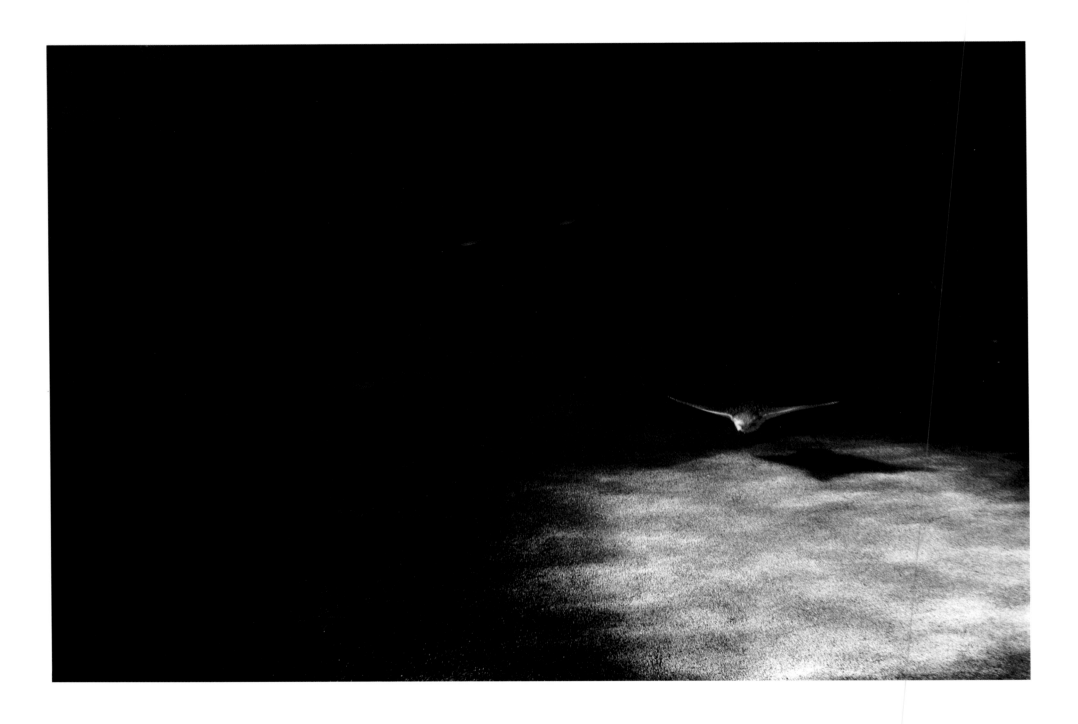

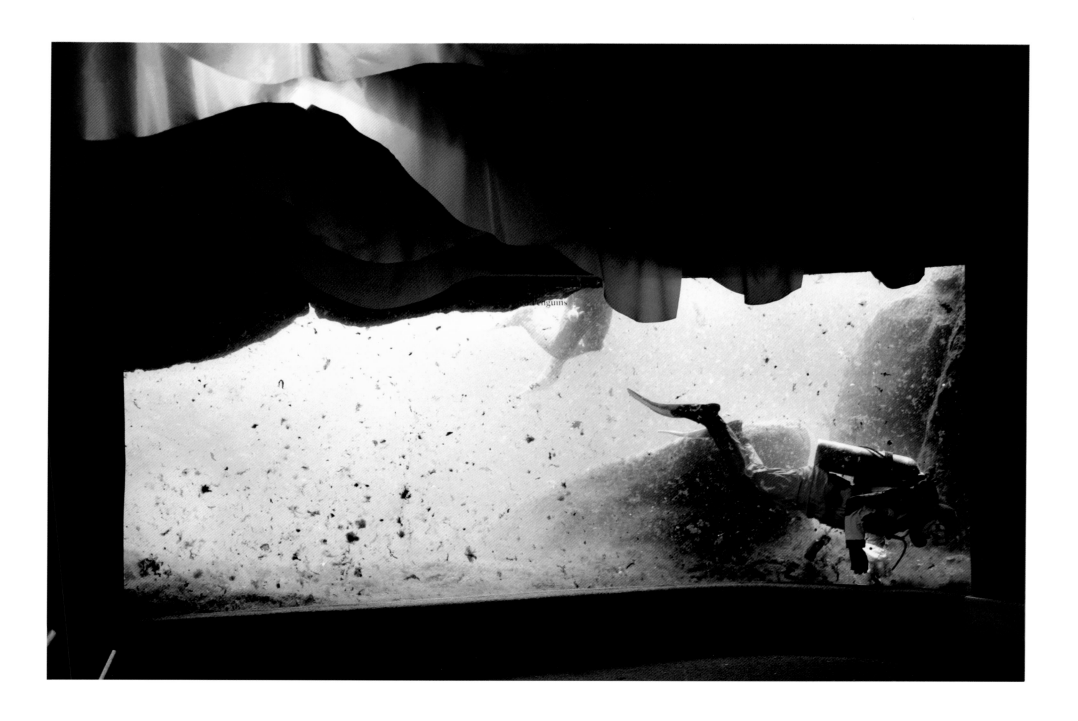

31

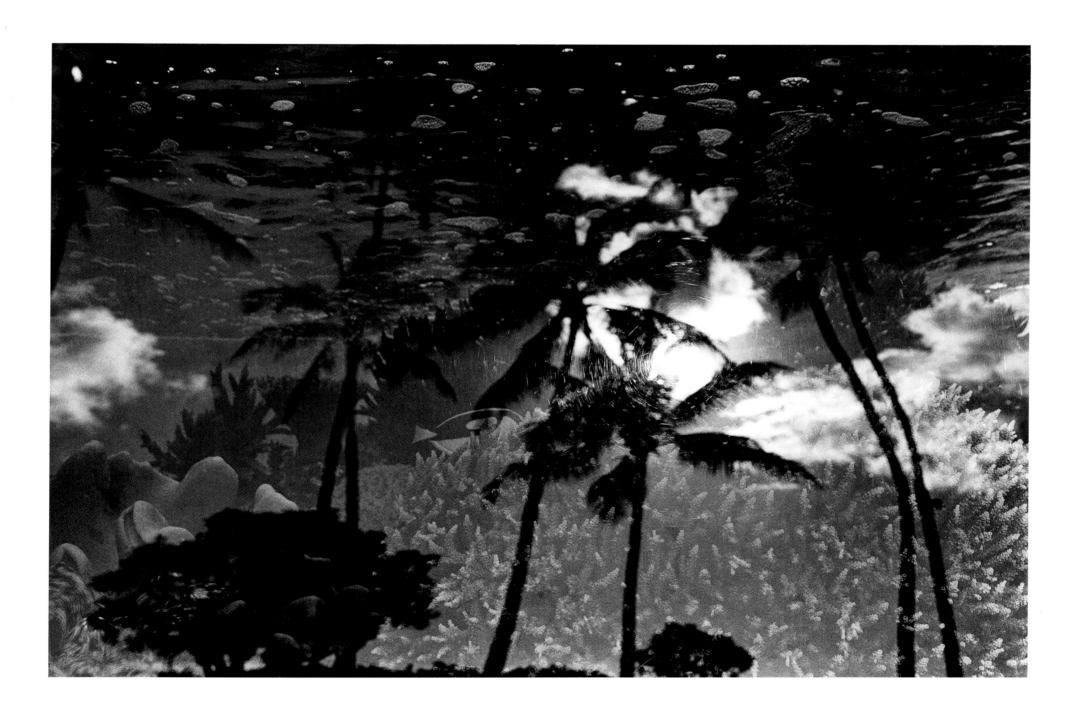

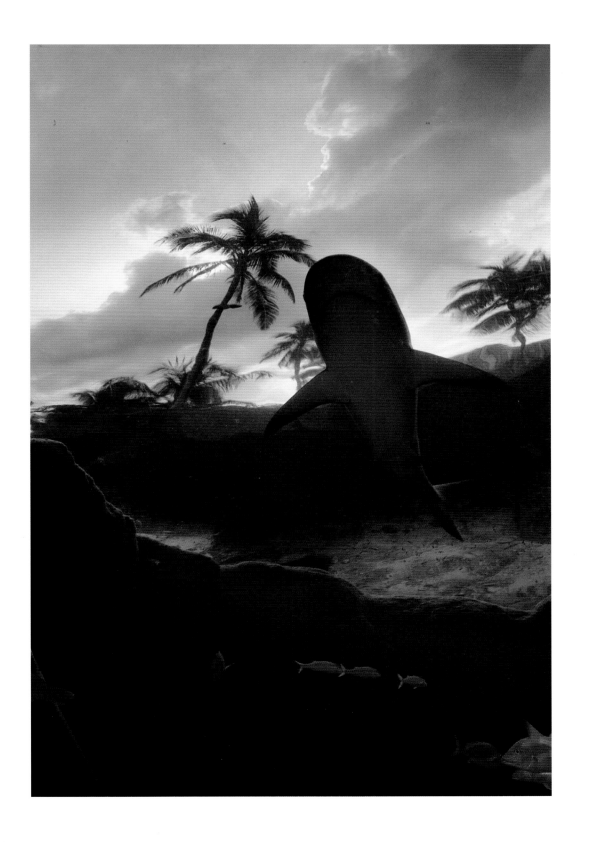

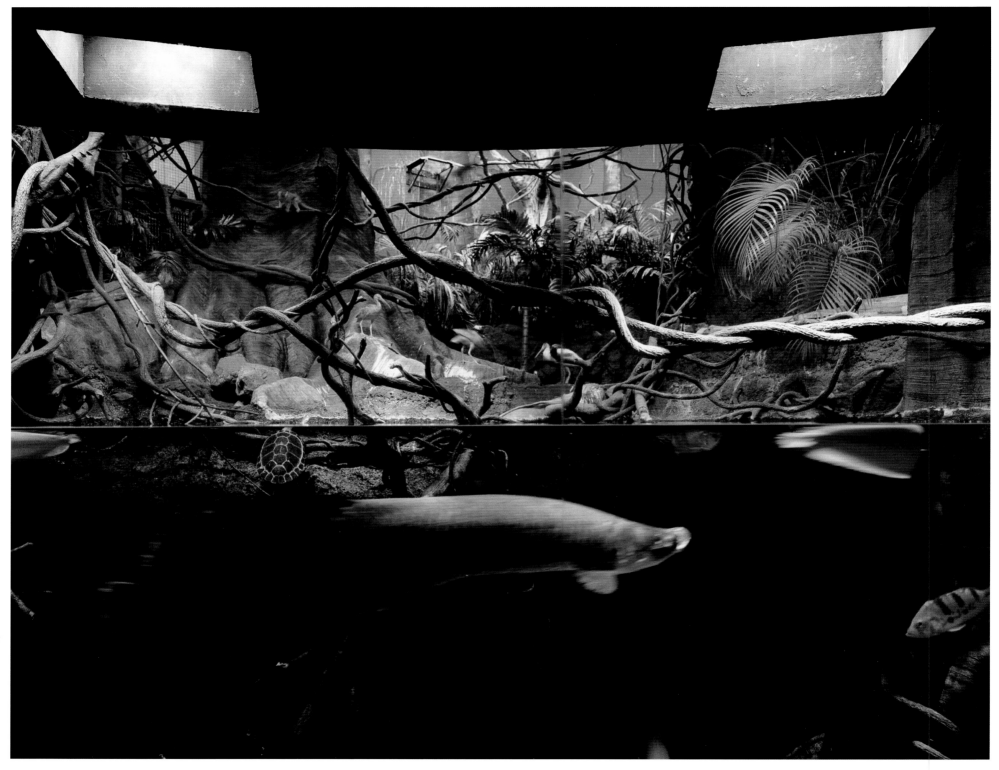

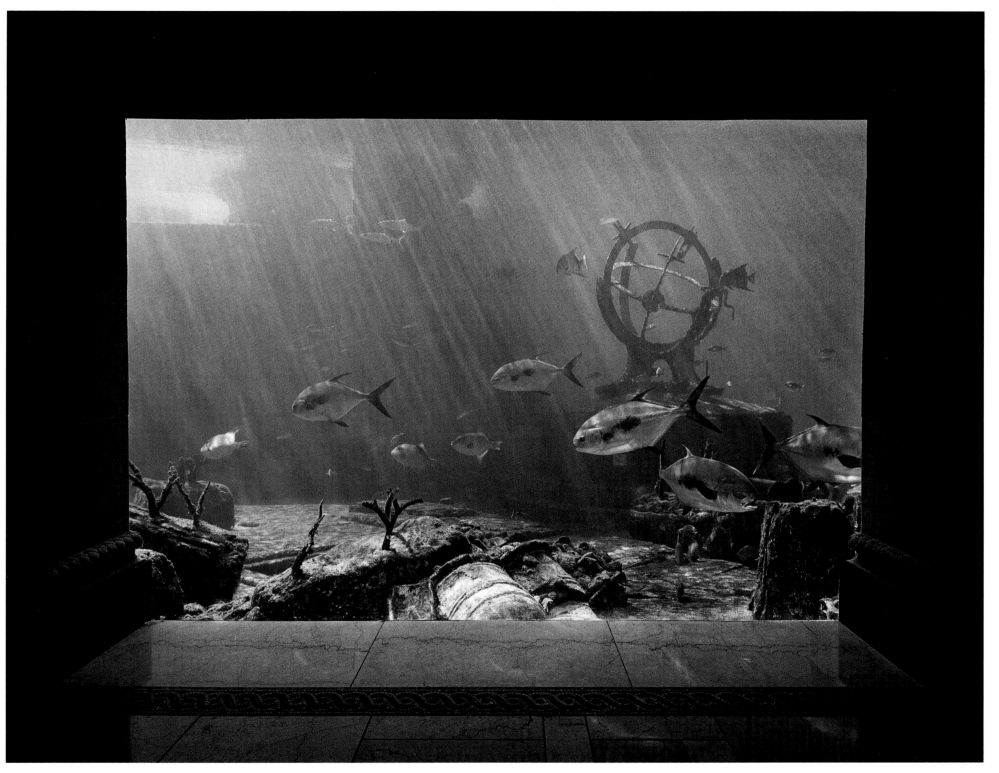

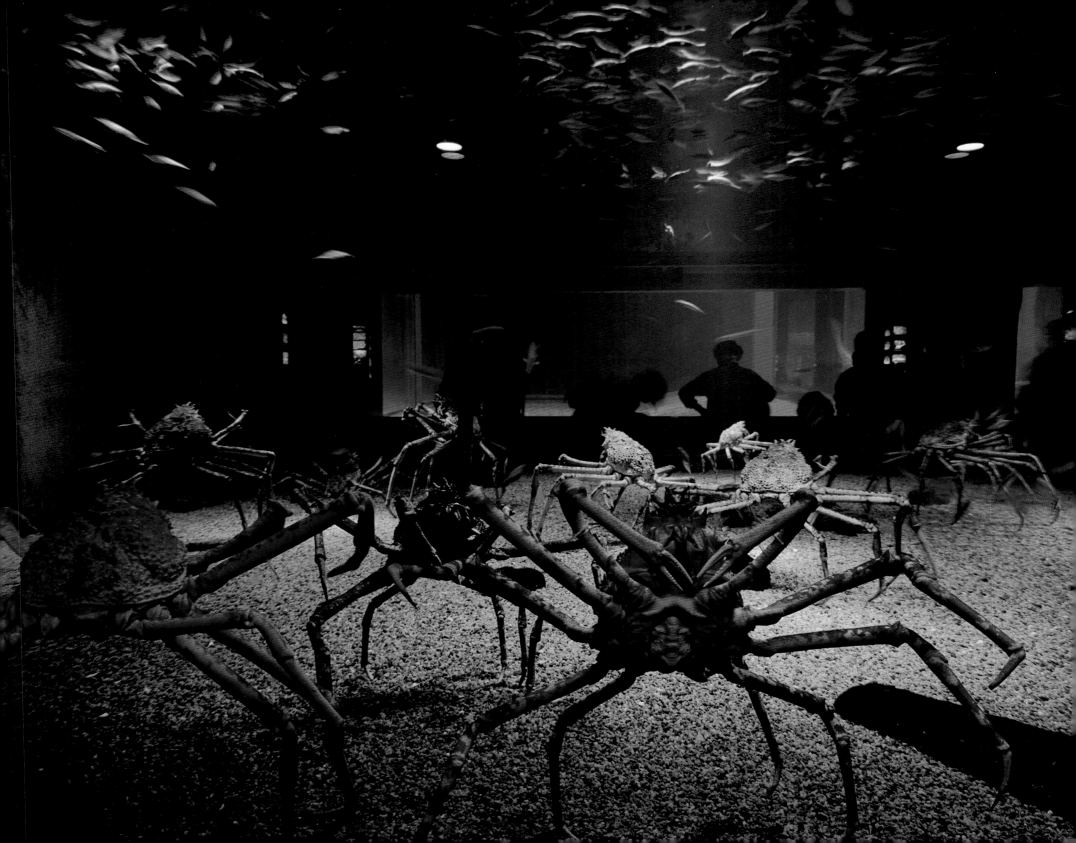

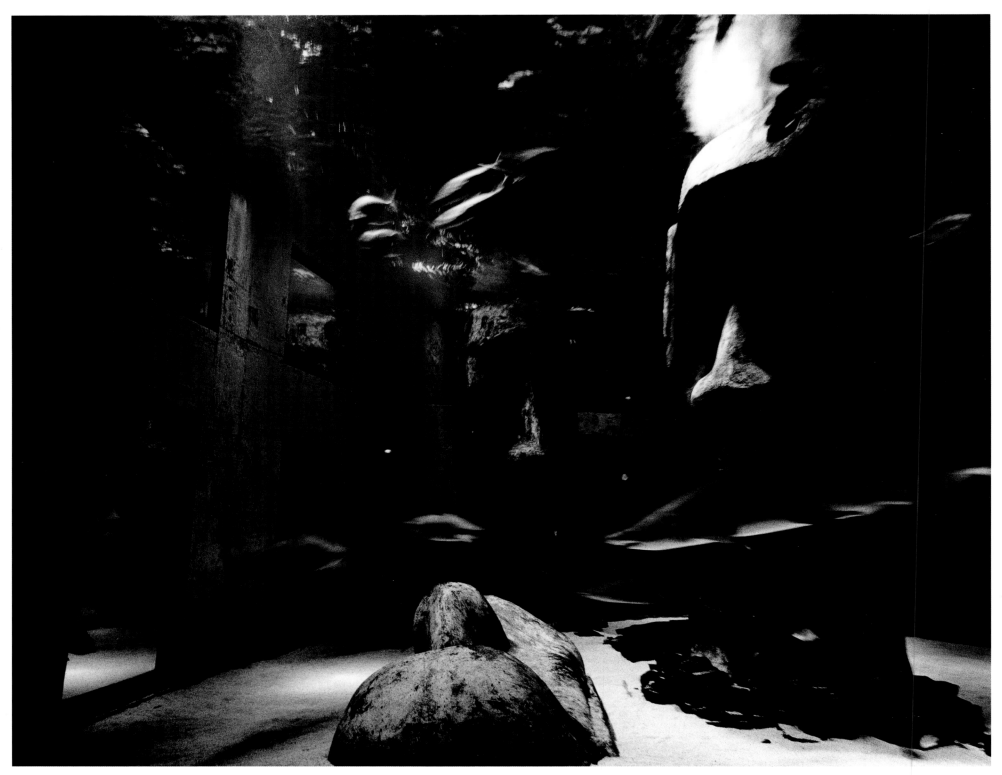

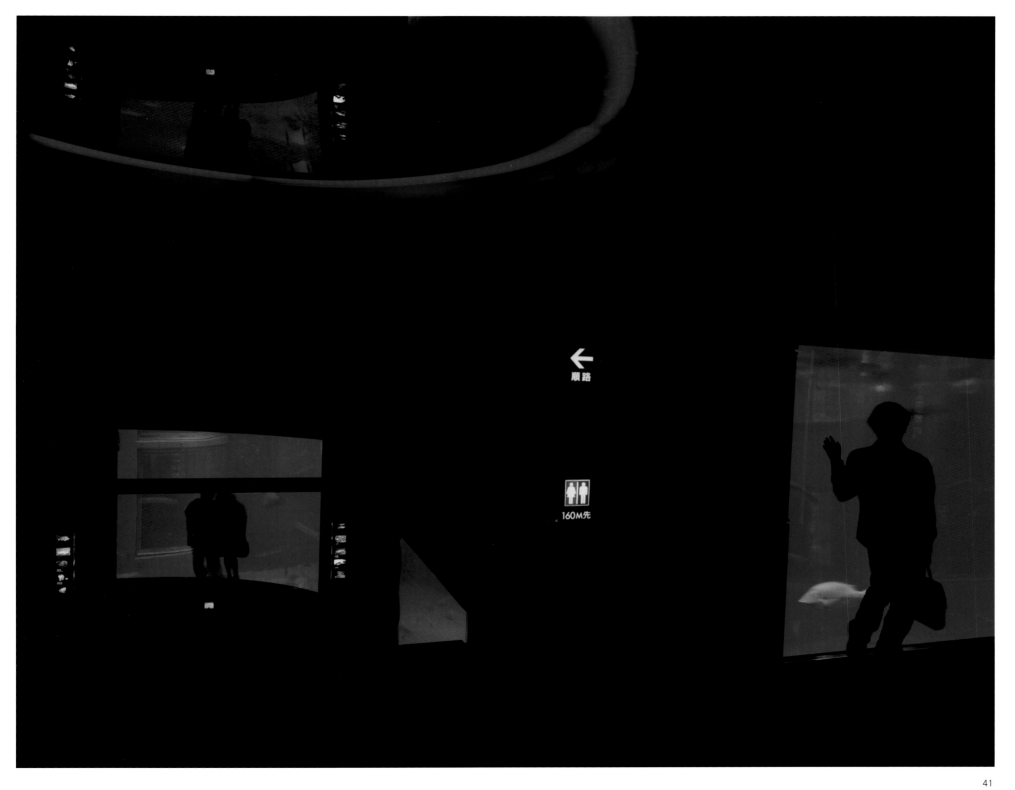

順路

160M先

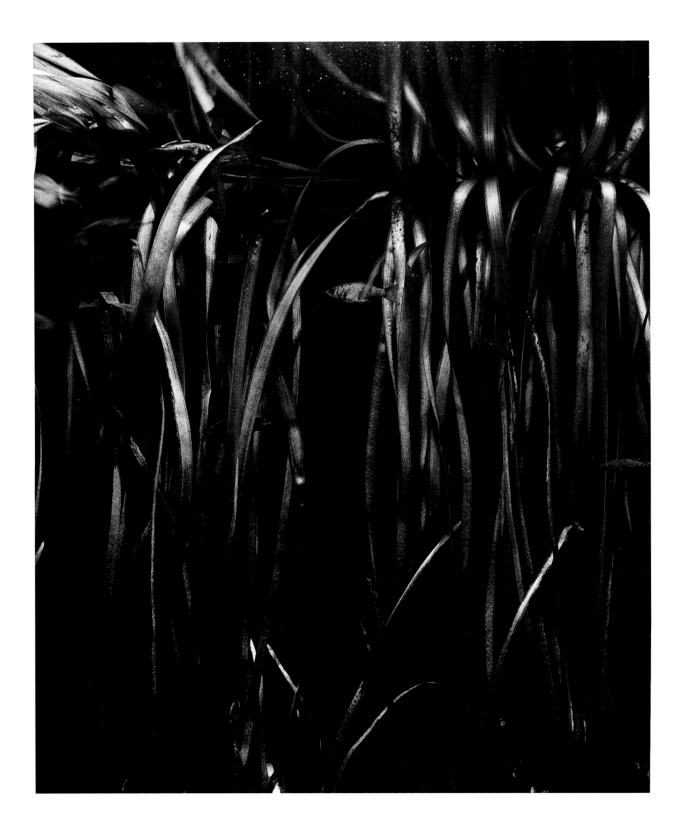

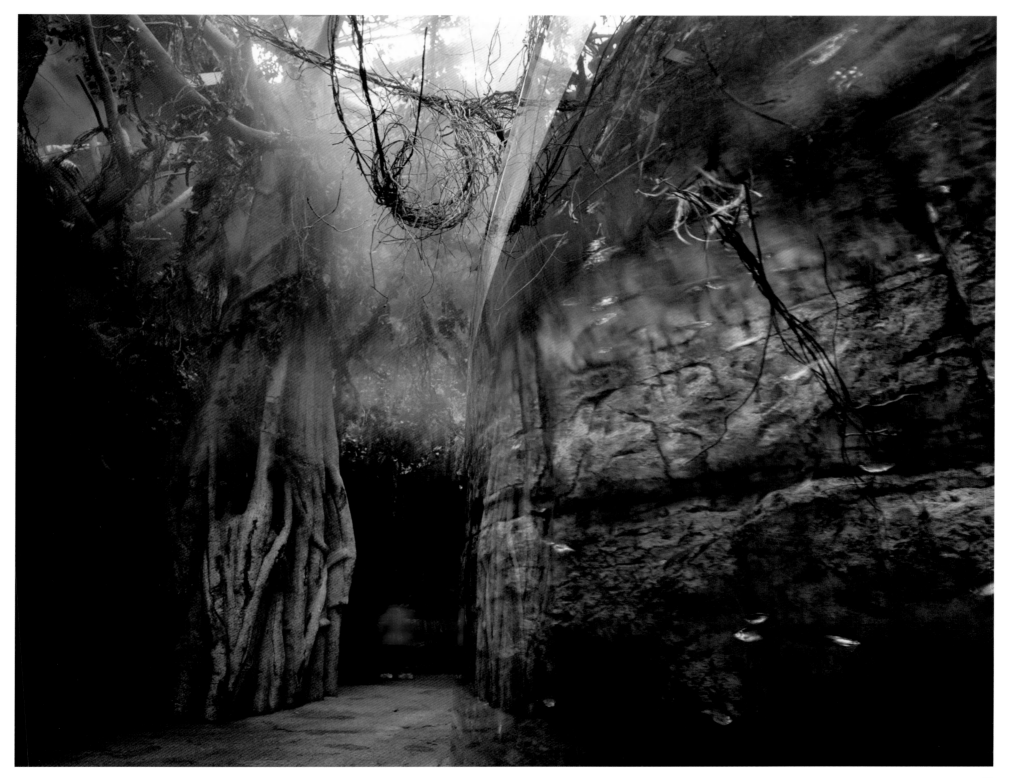

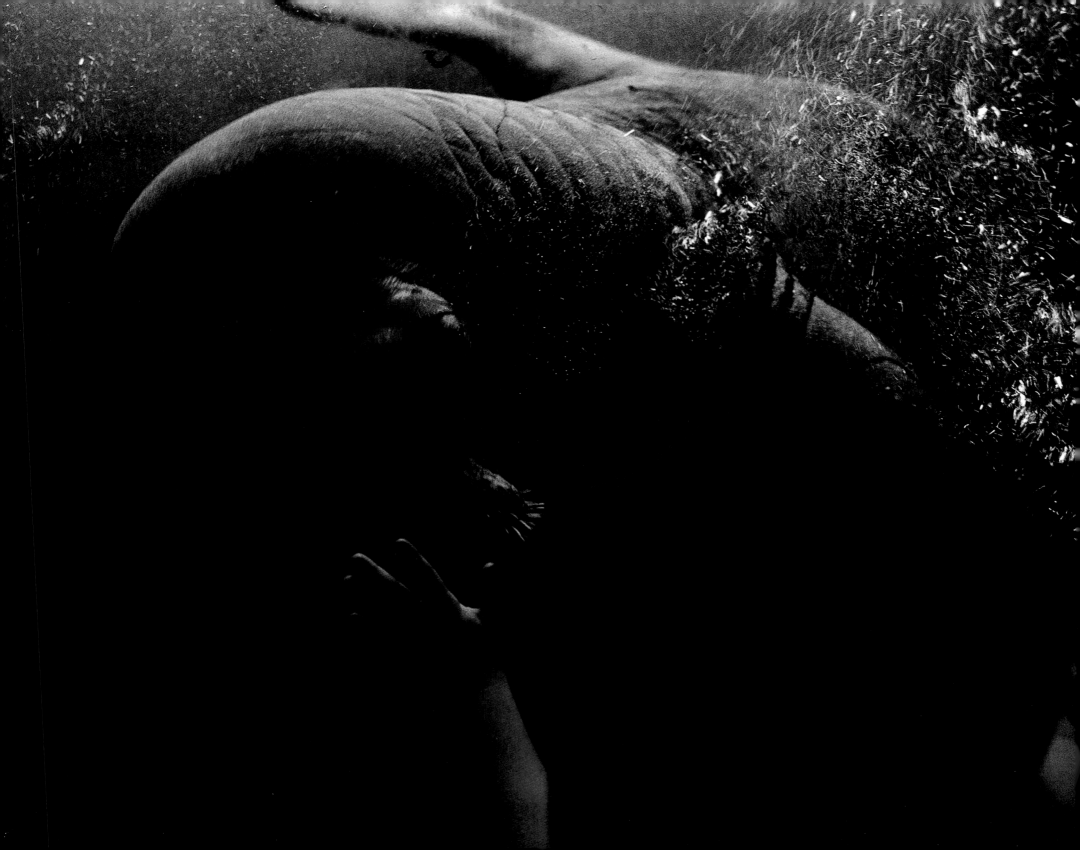

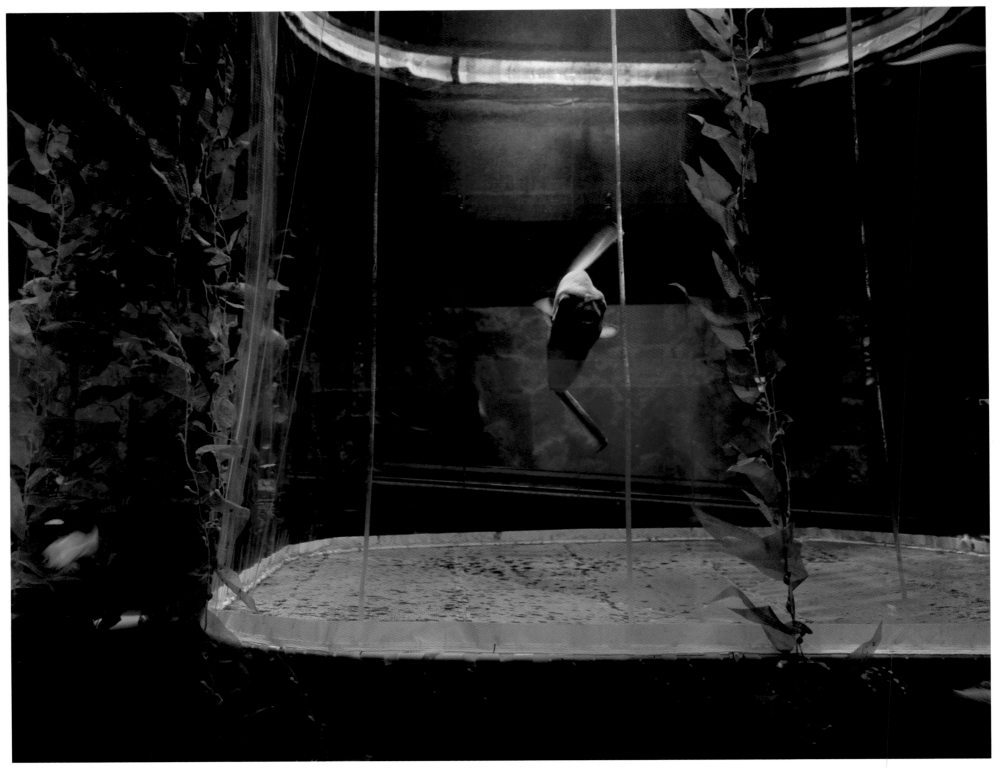

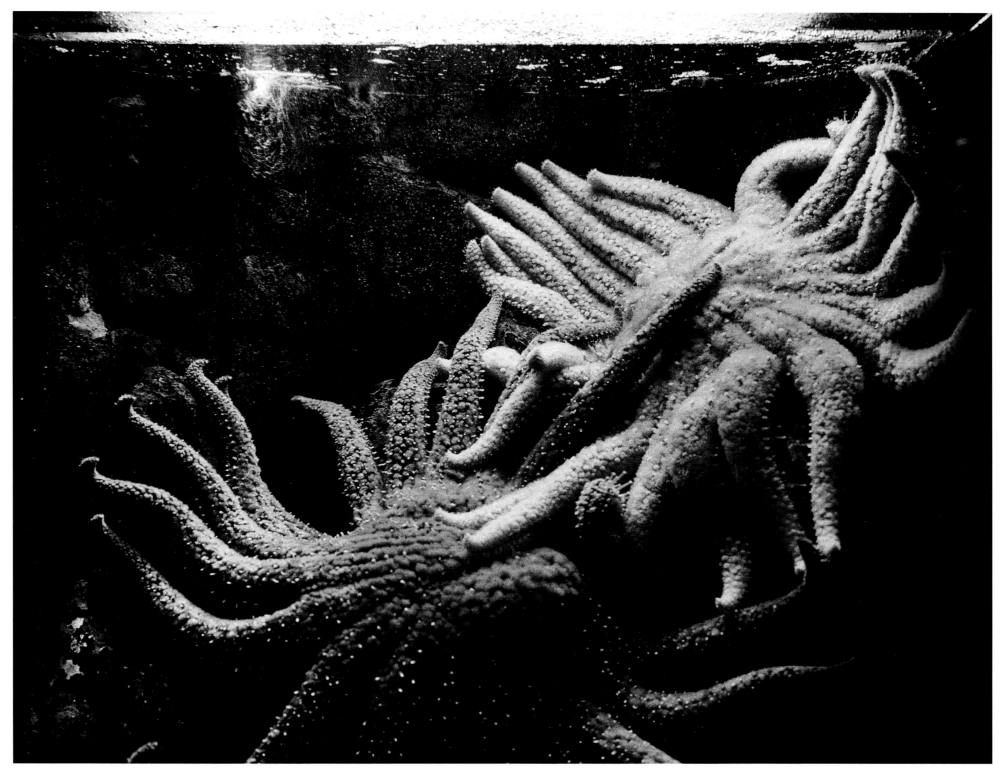

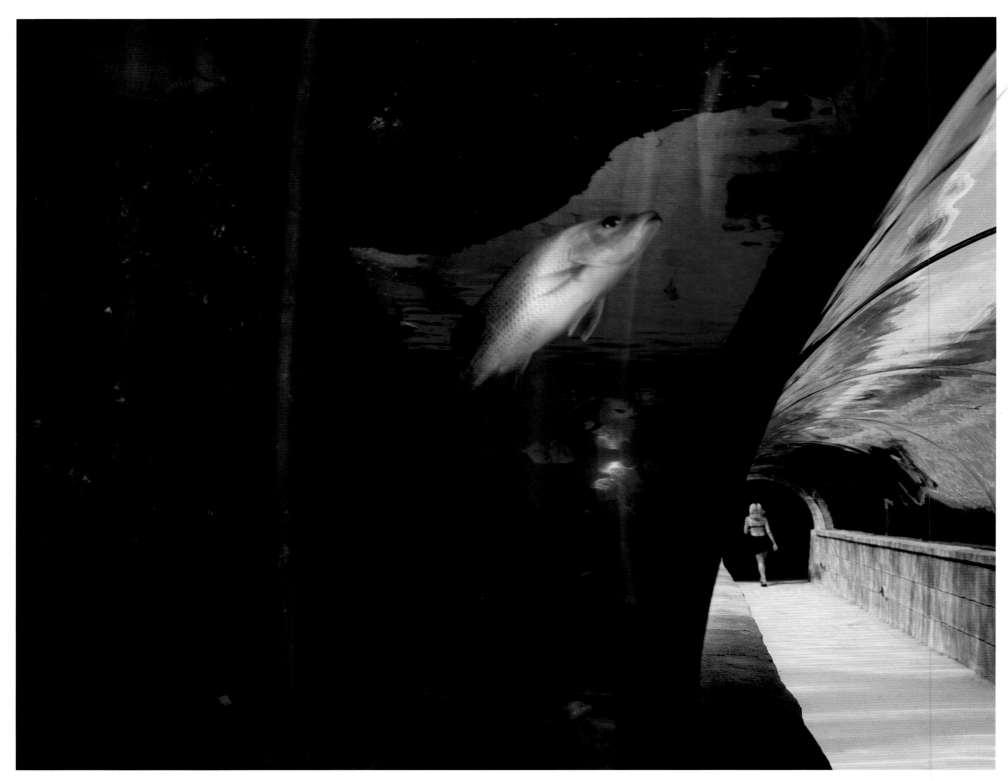

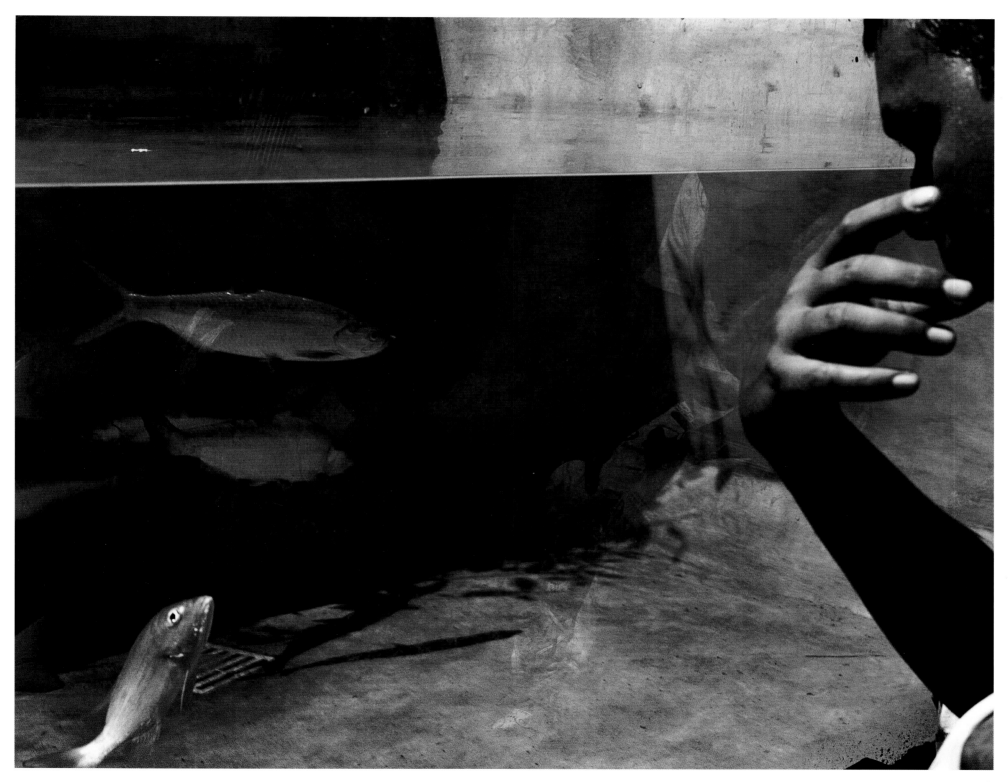

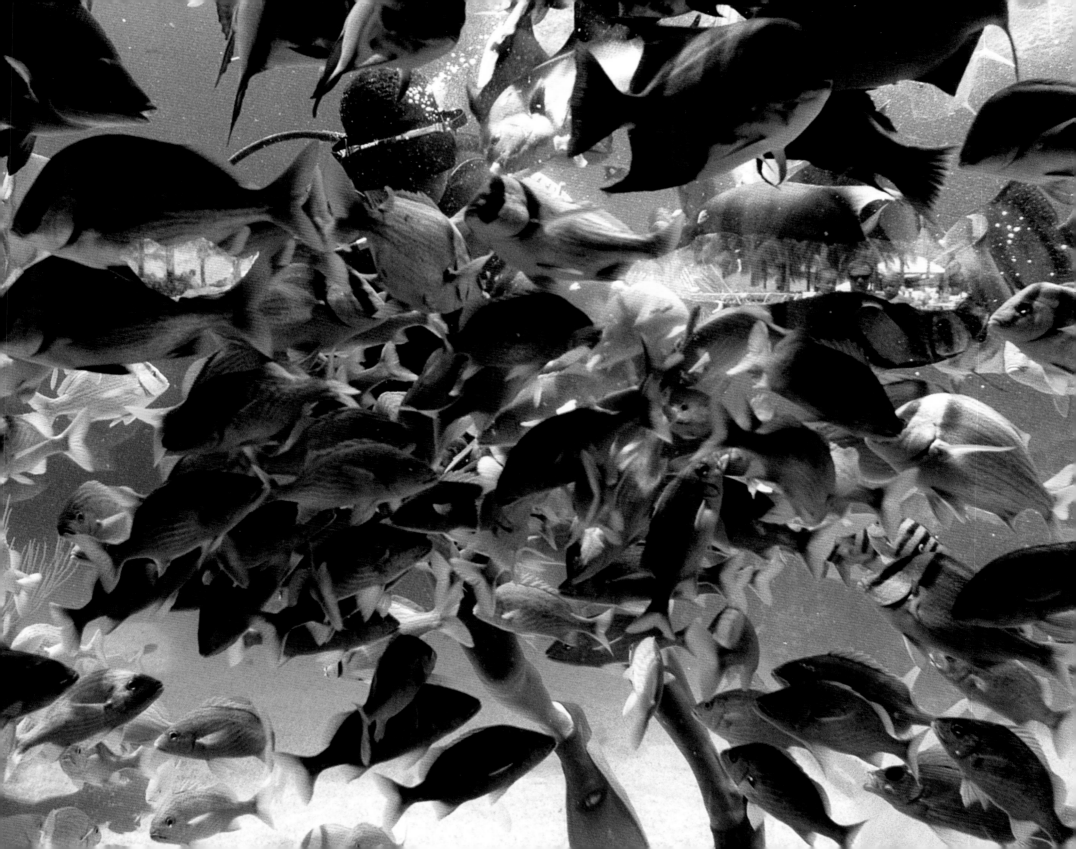

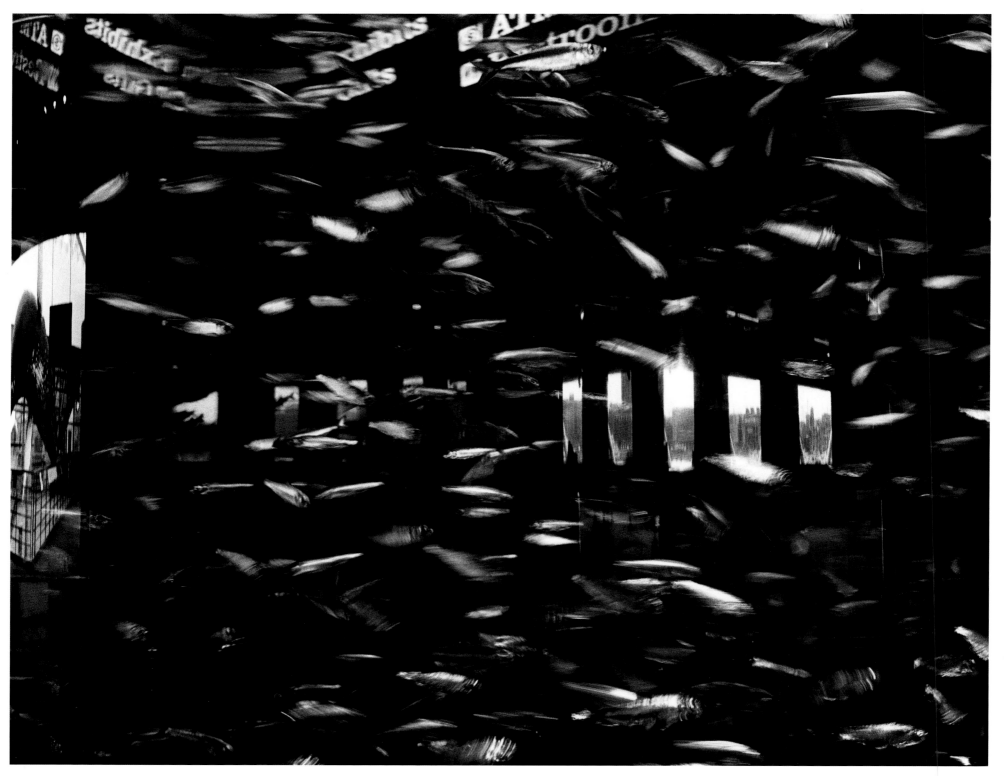

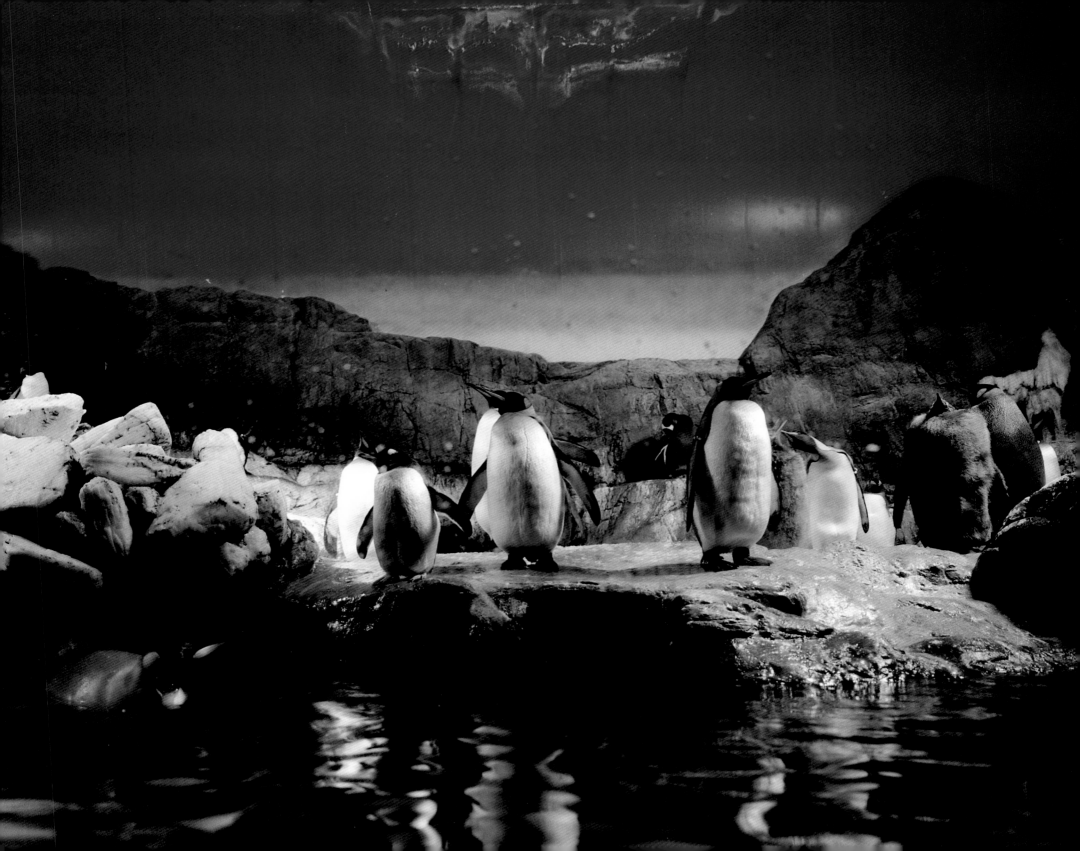

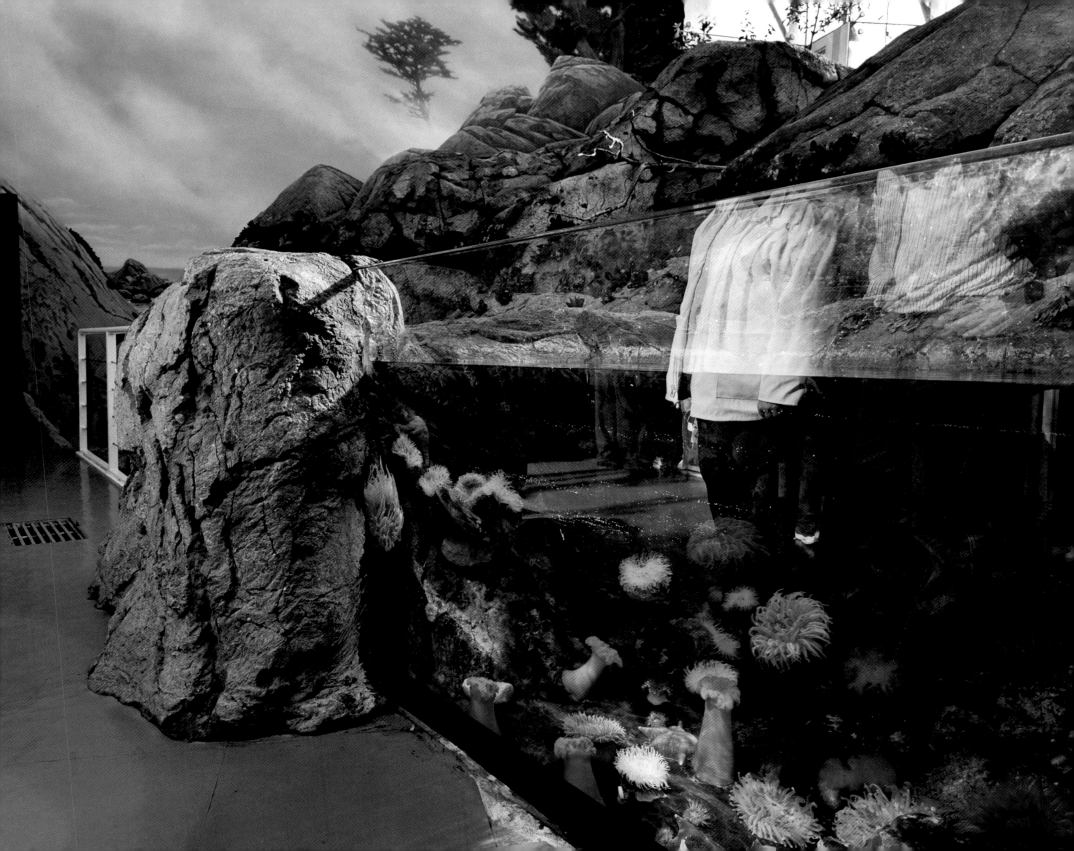

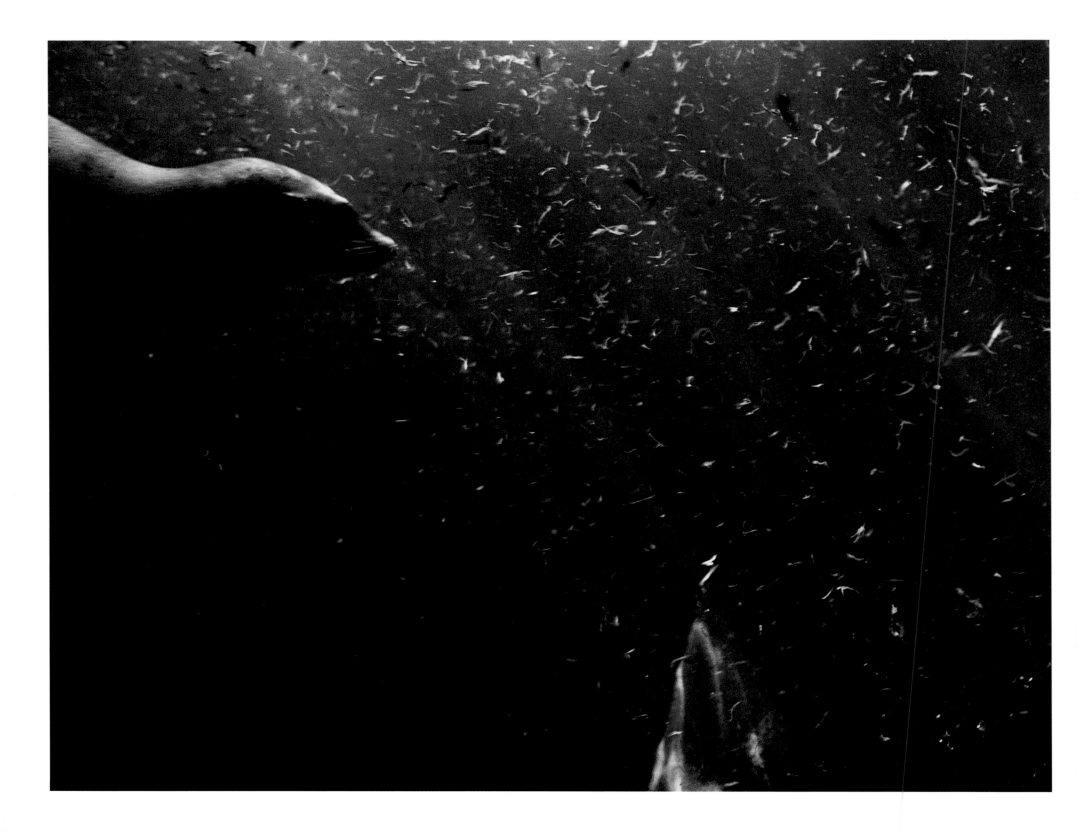

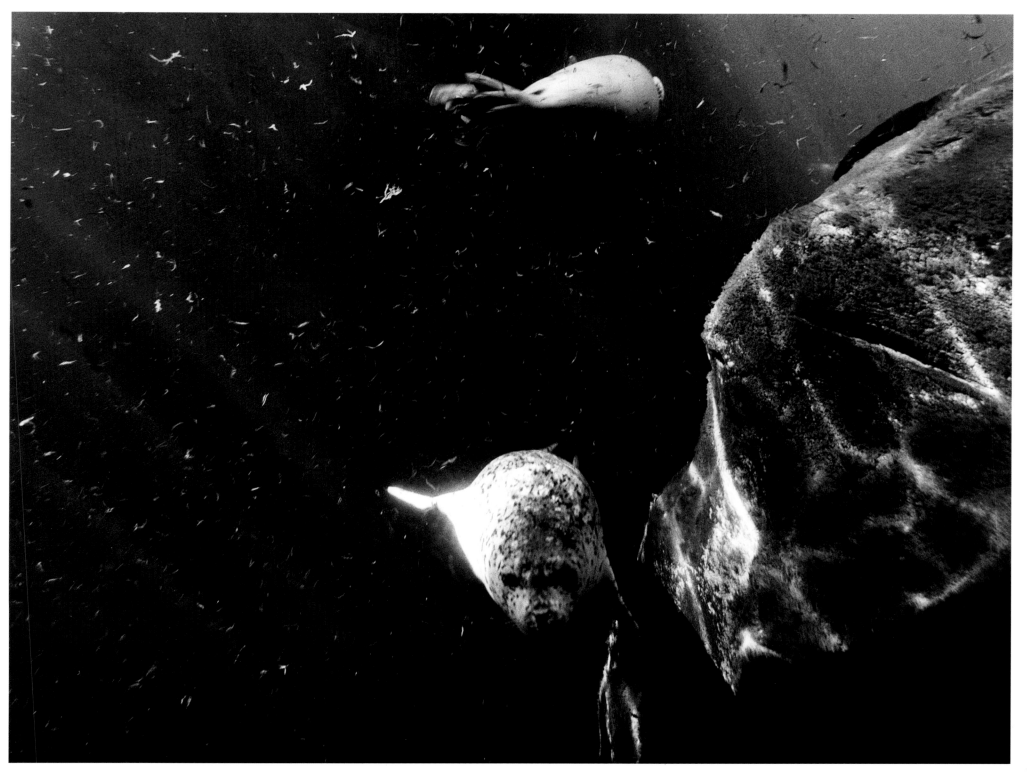

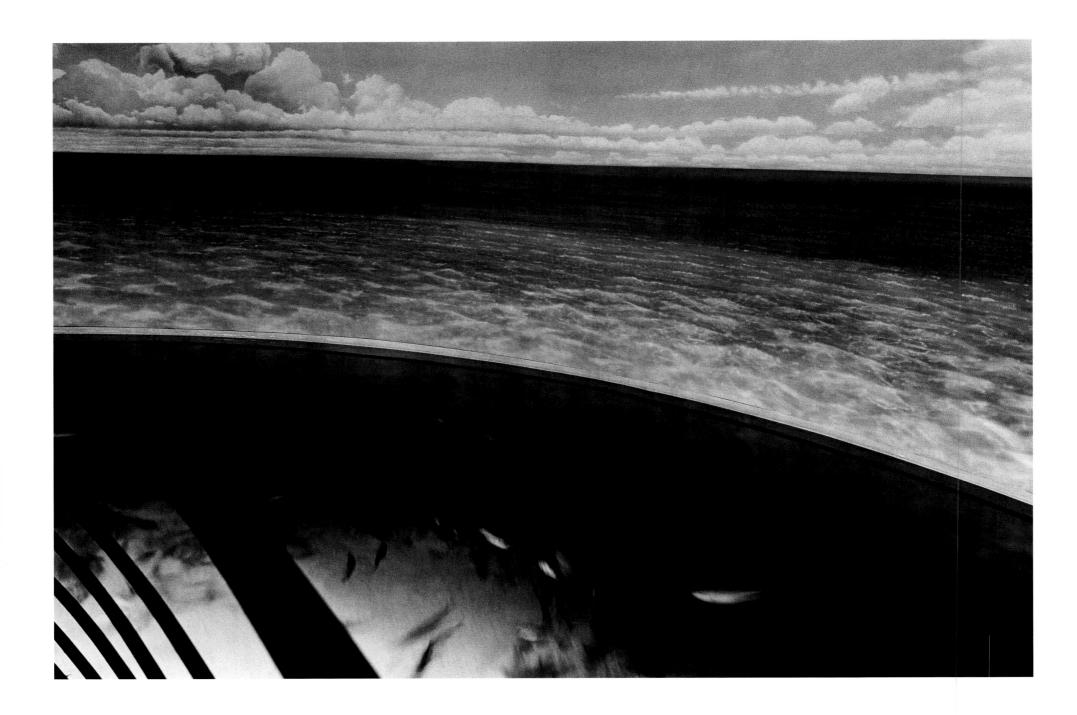

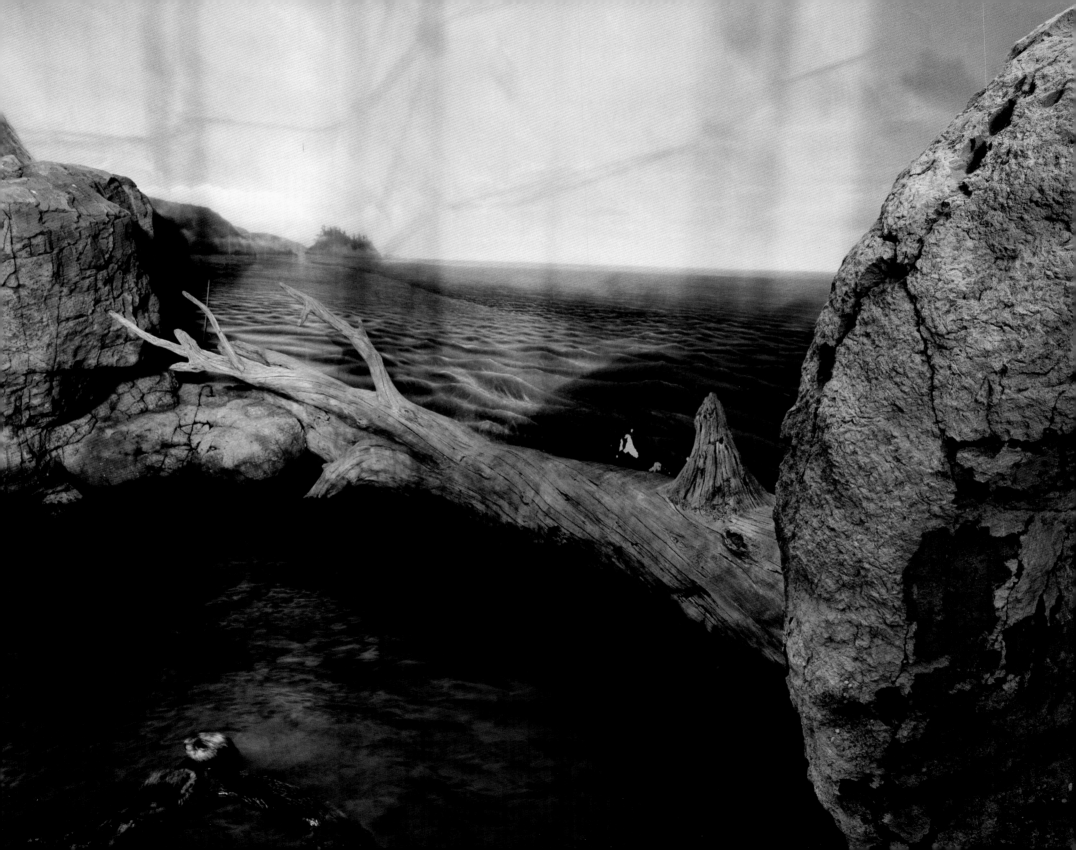

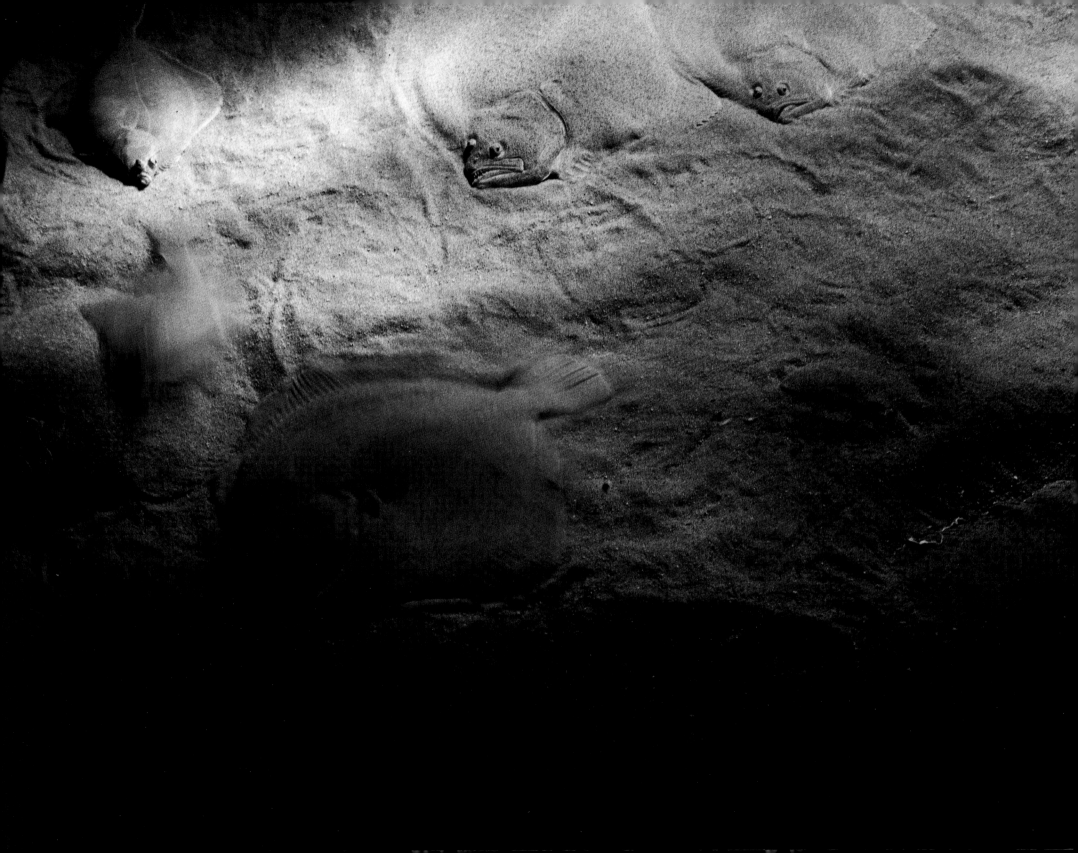

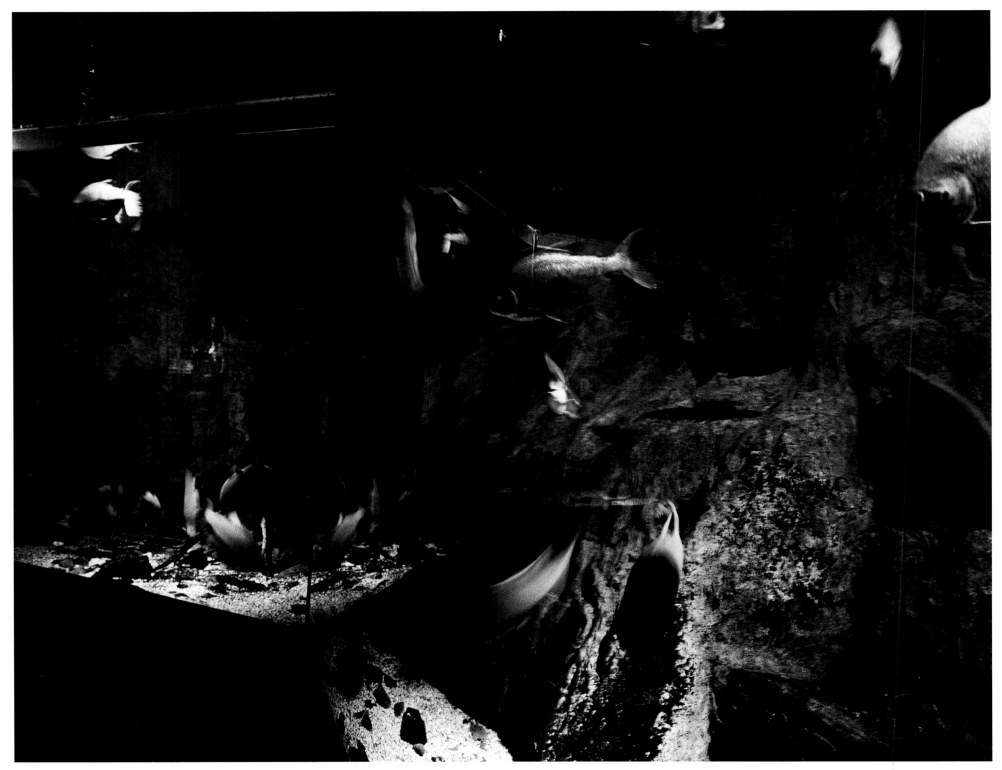

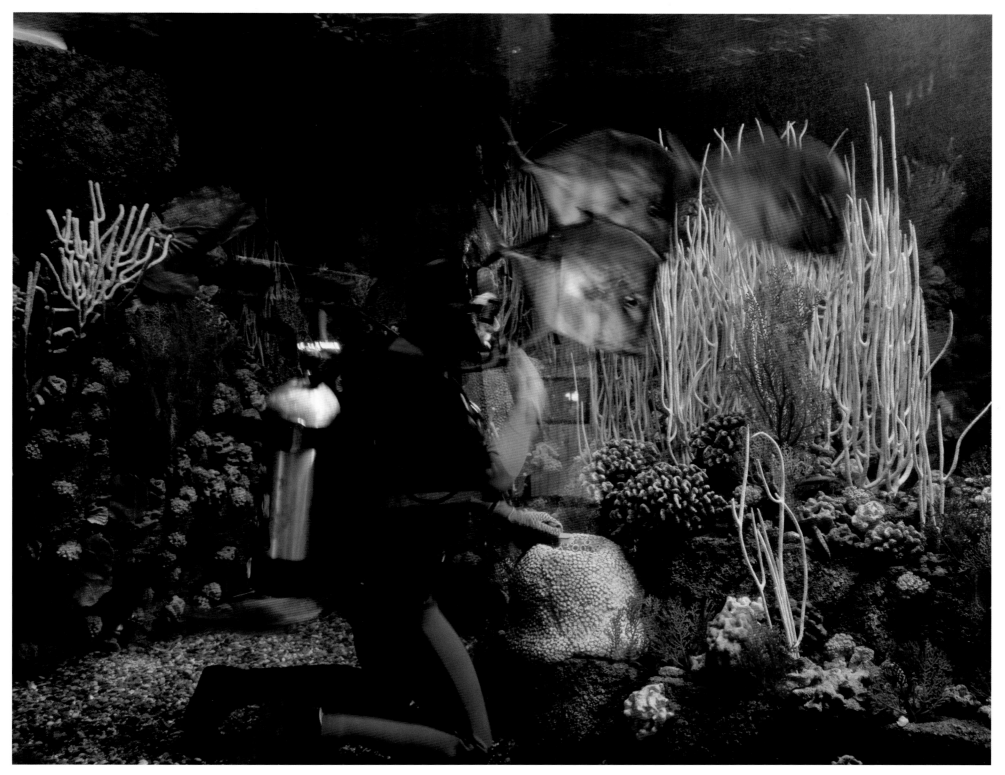

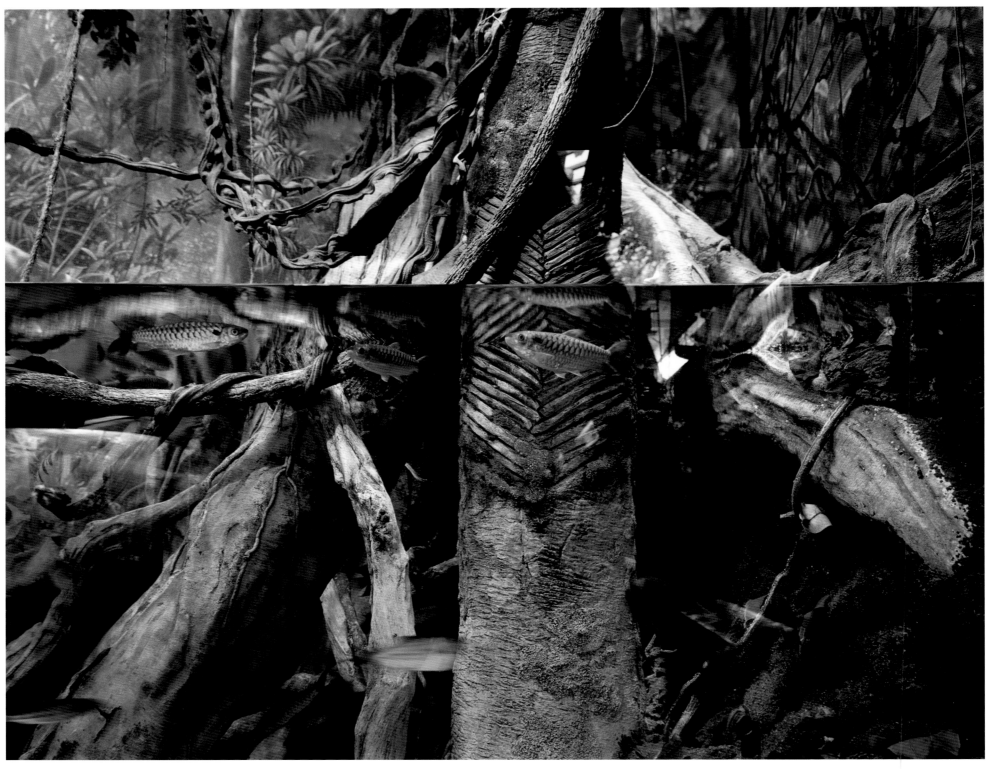

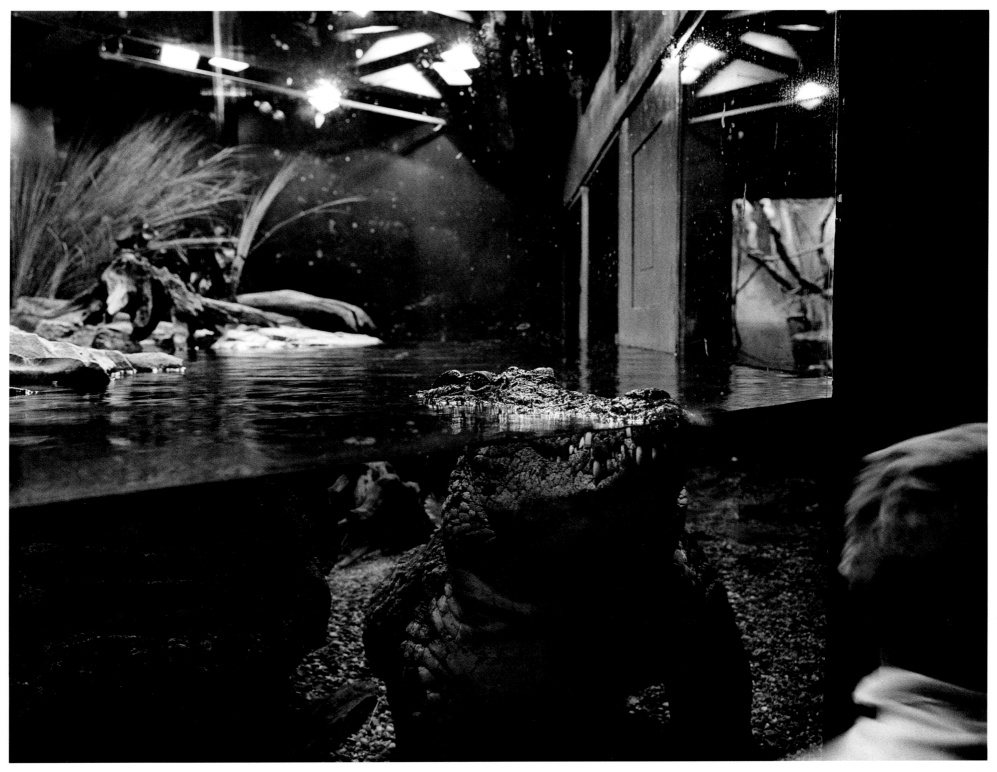

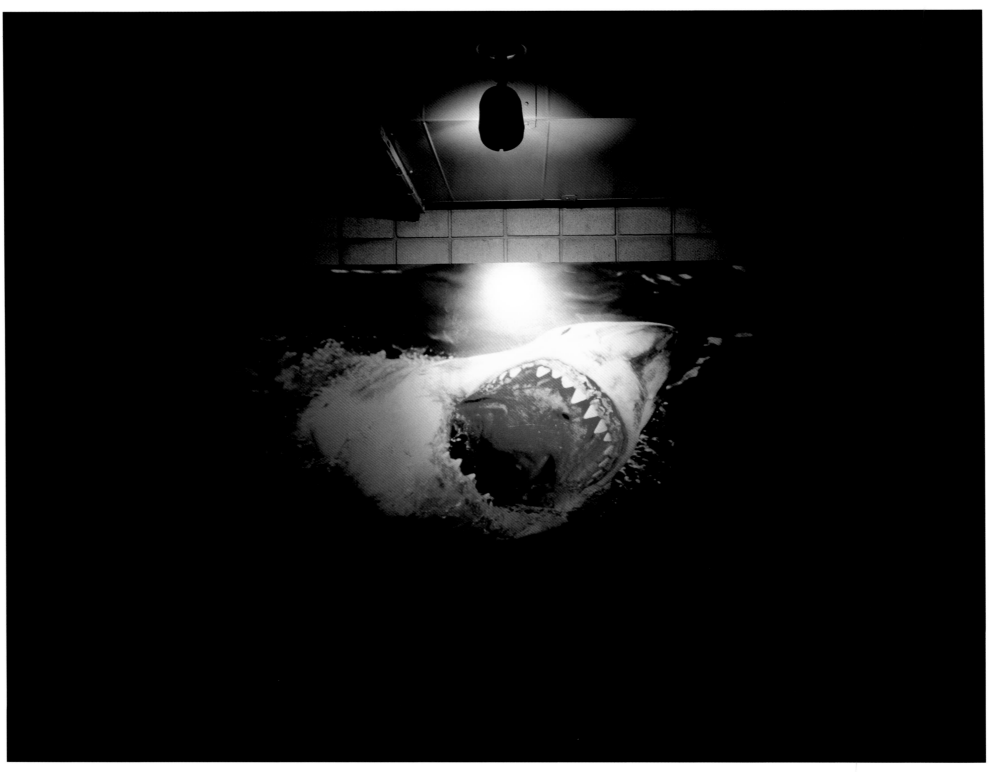

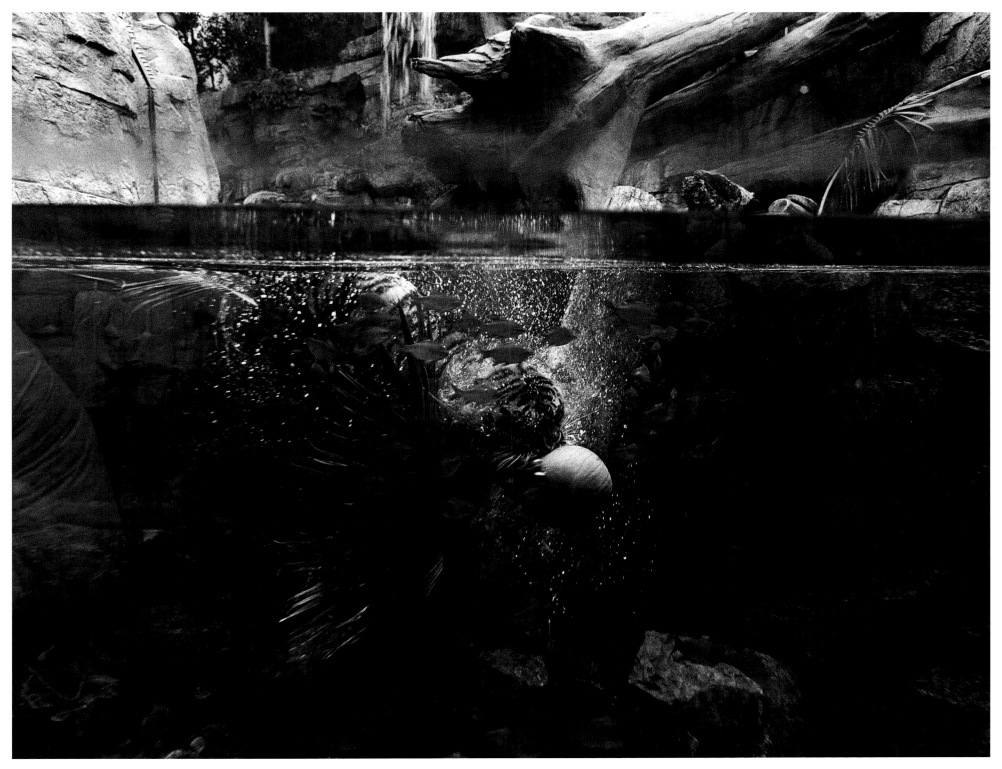

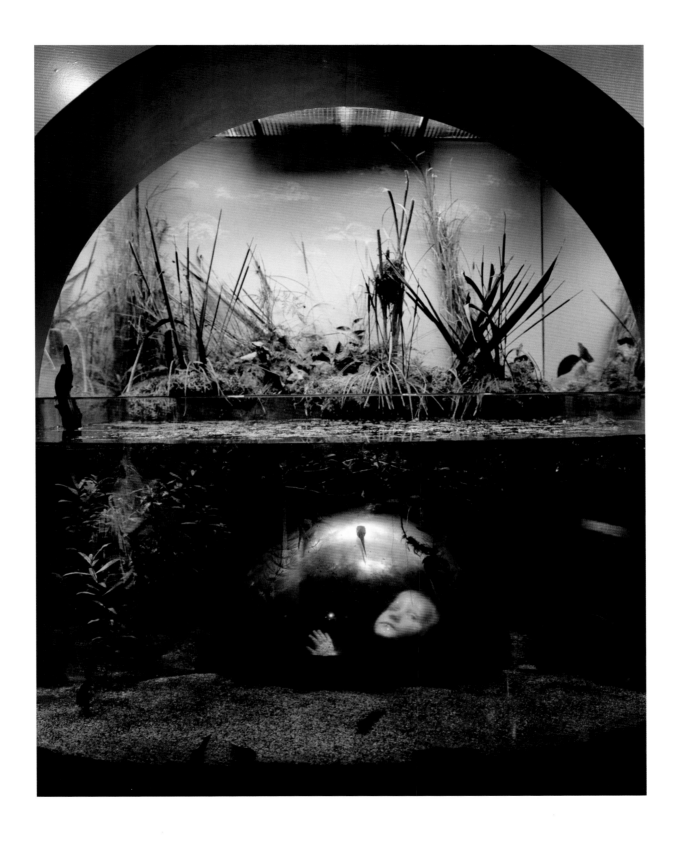

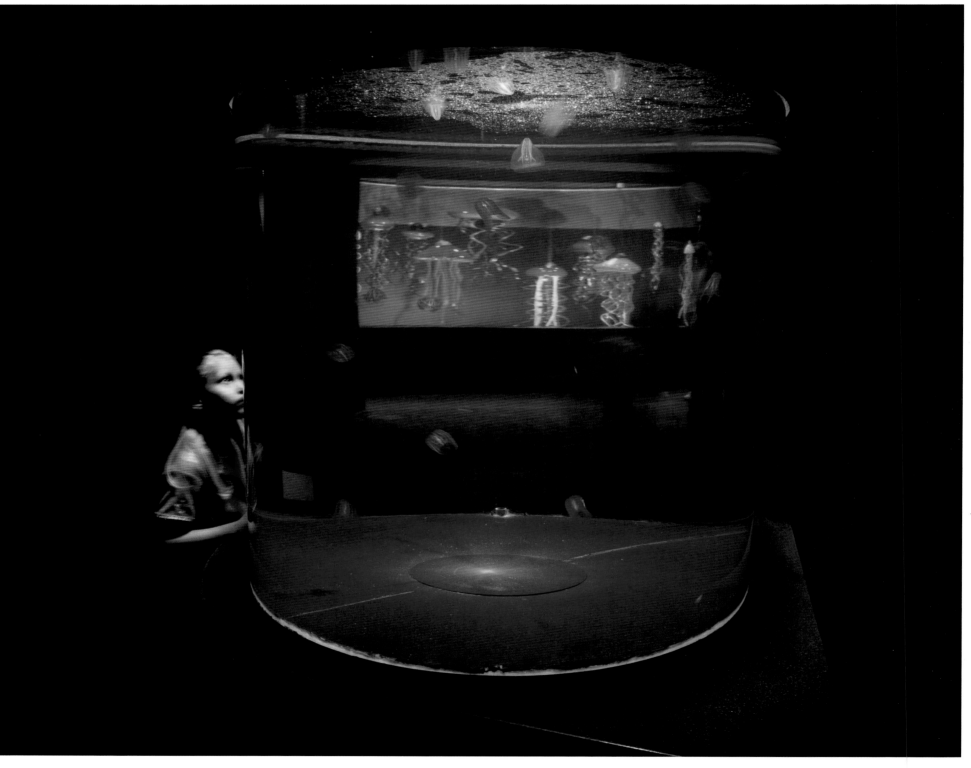

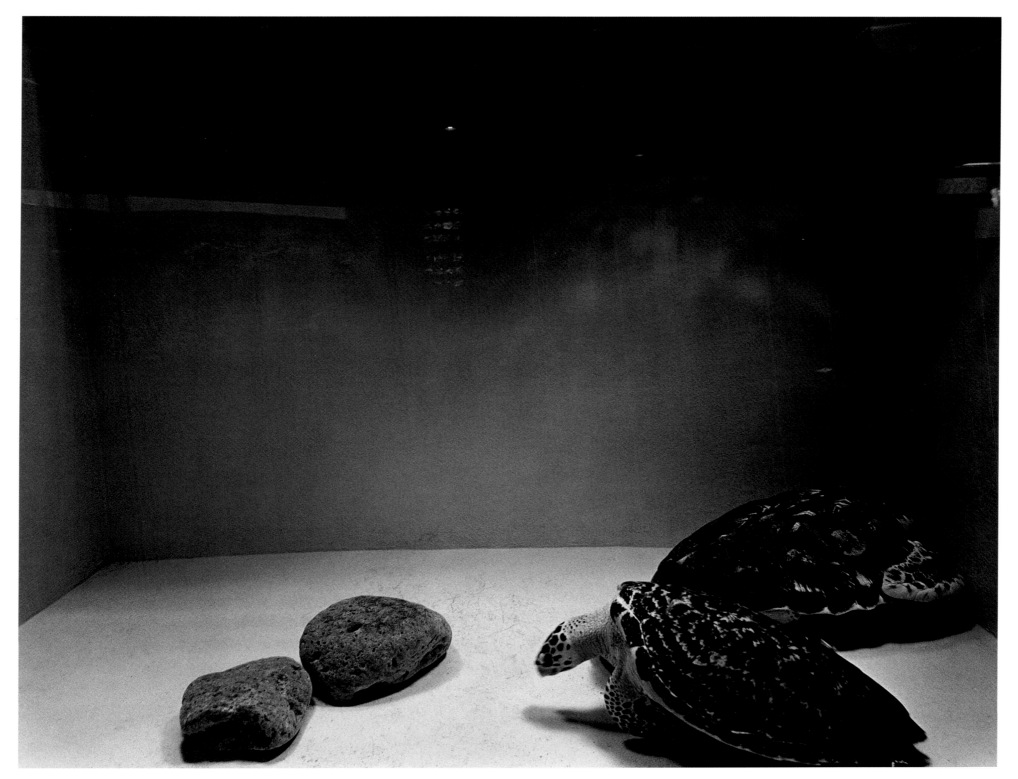

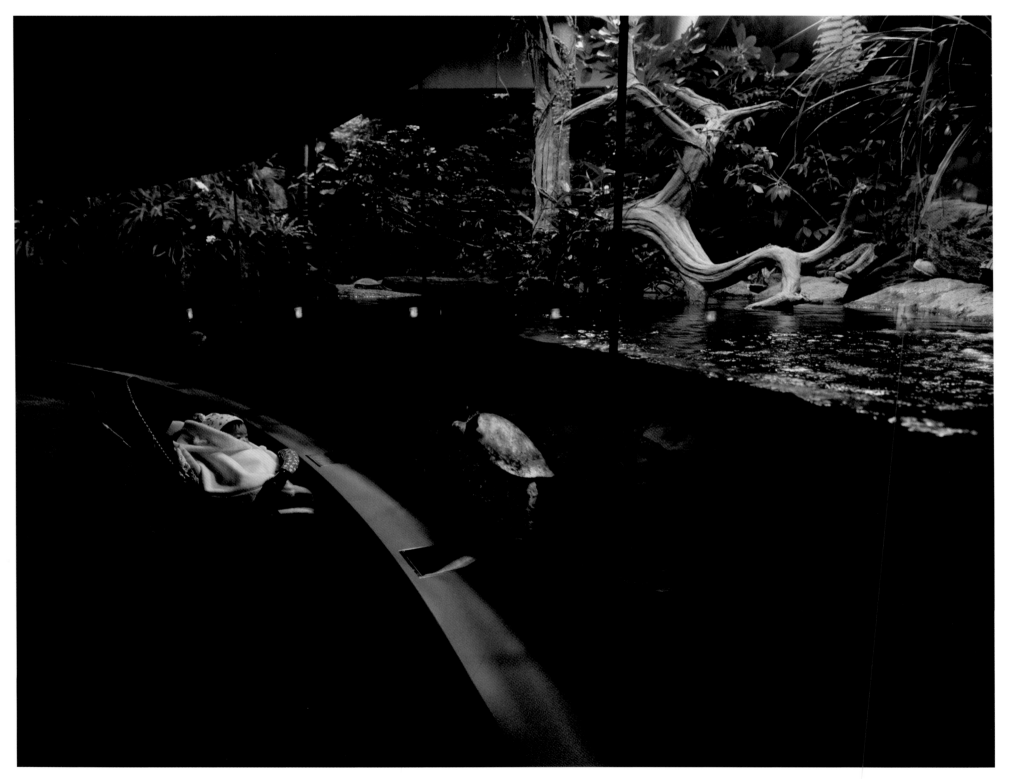

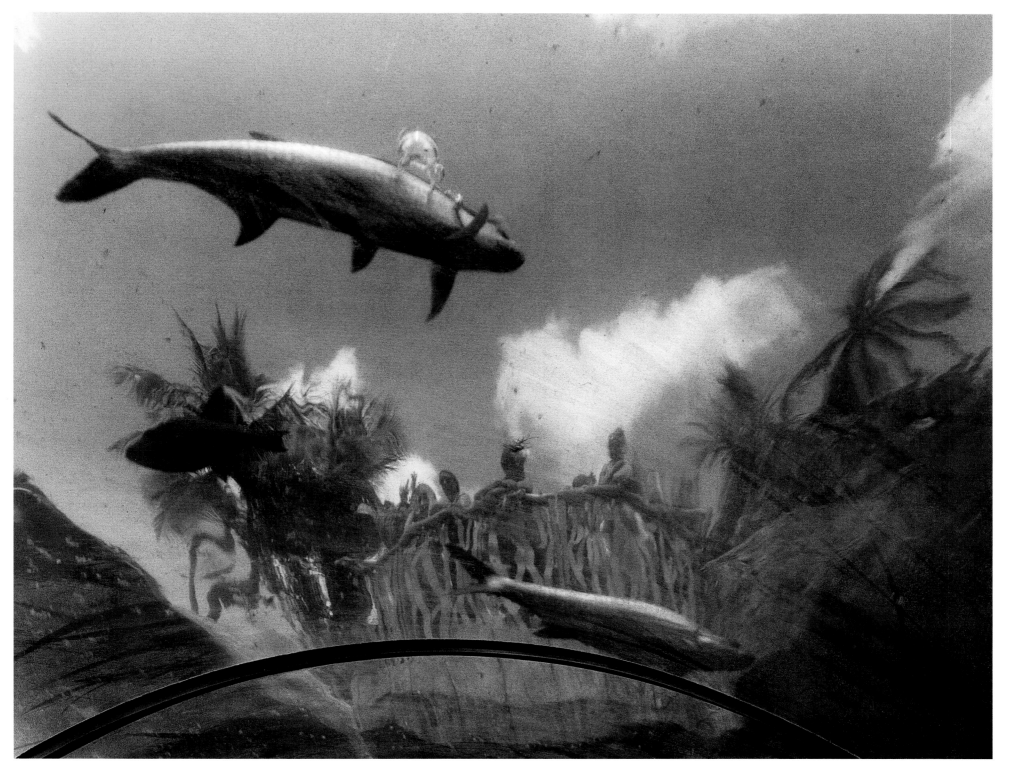

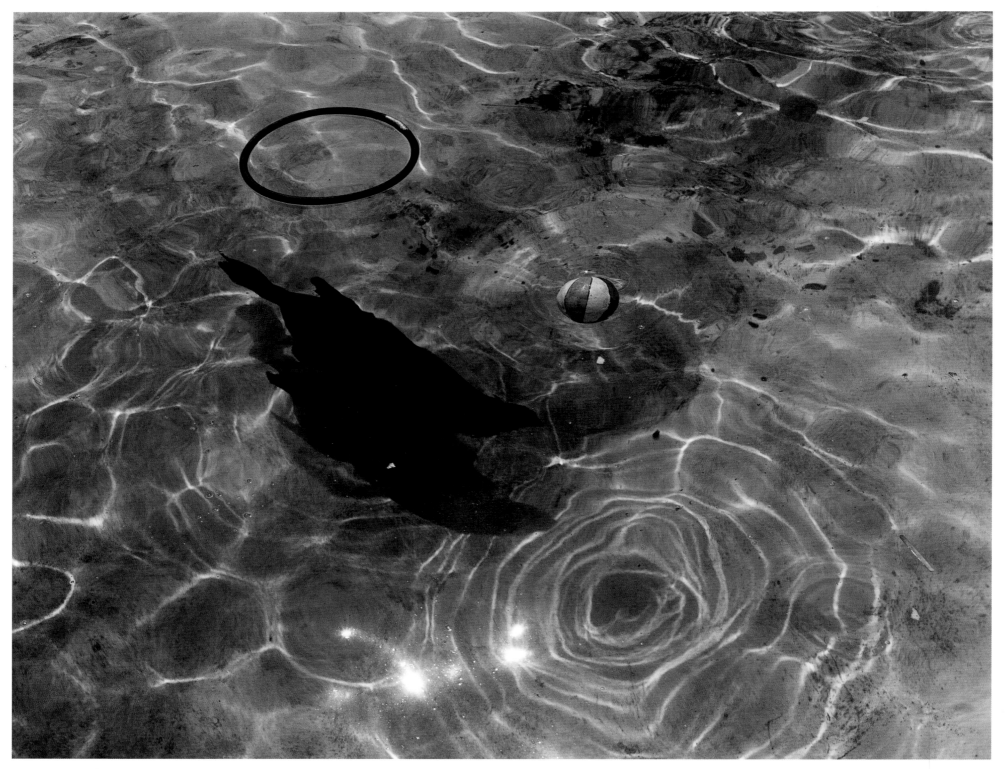

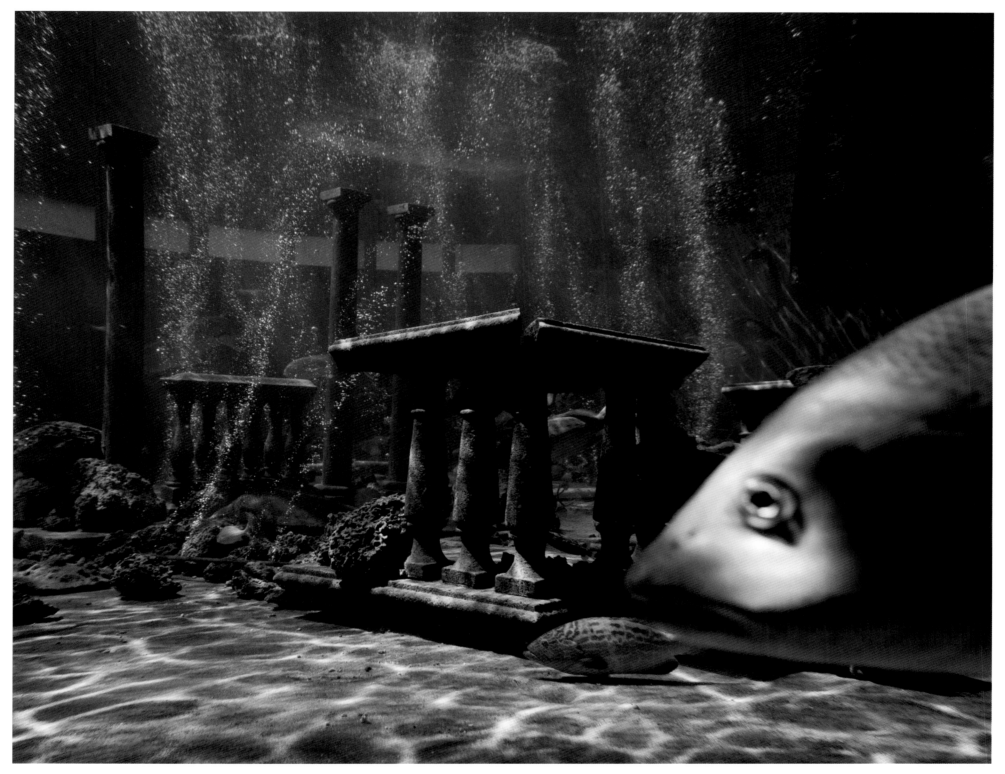

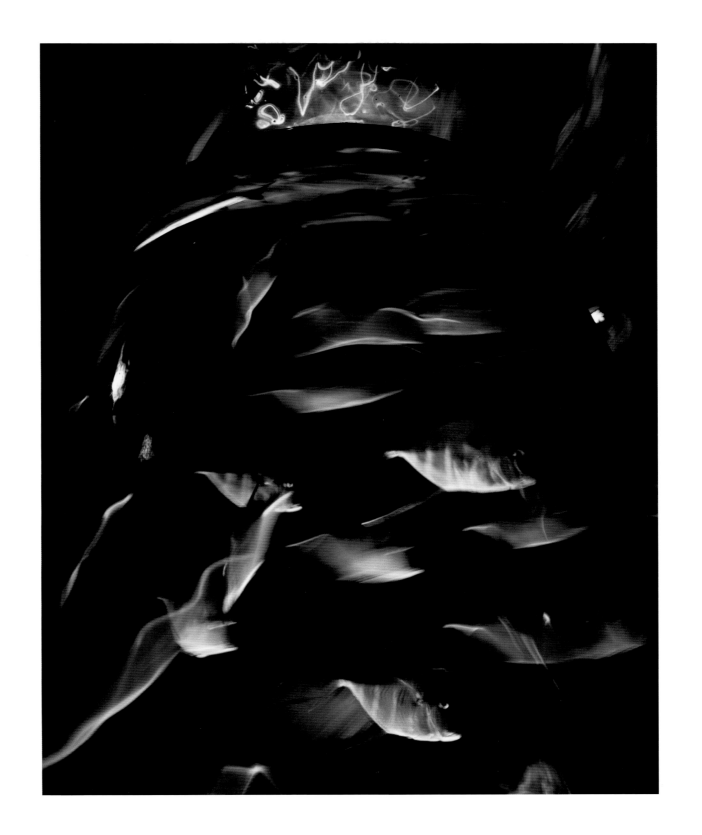

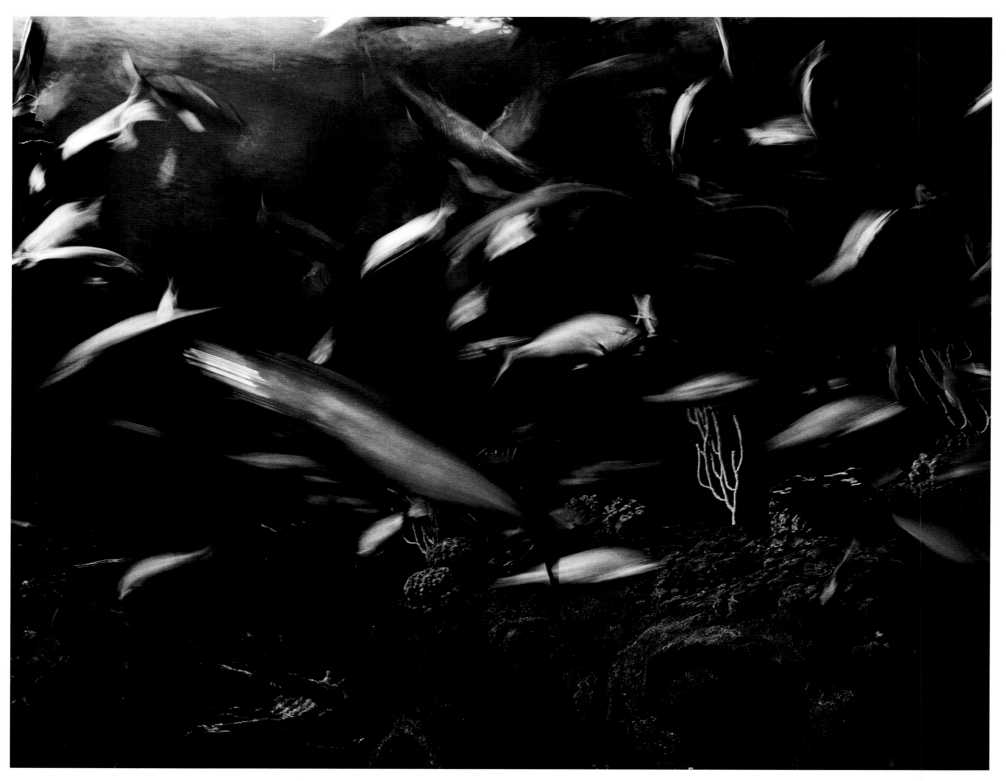

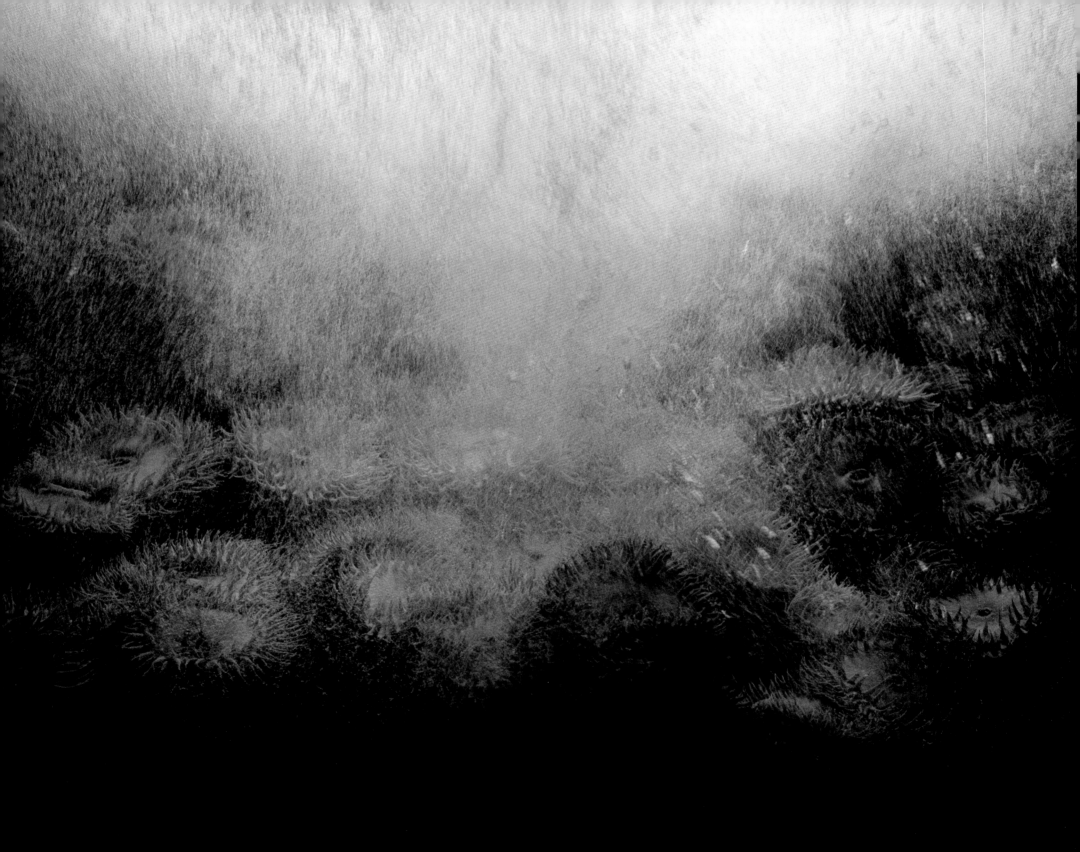

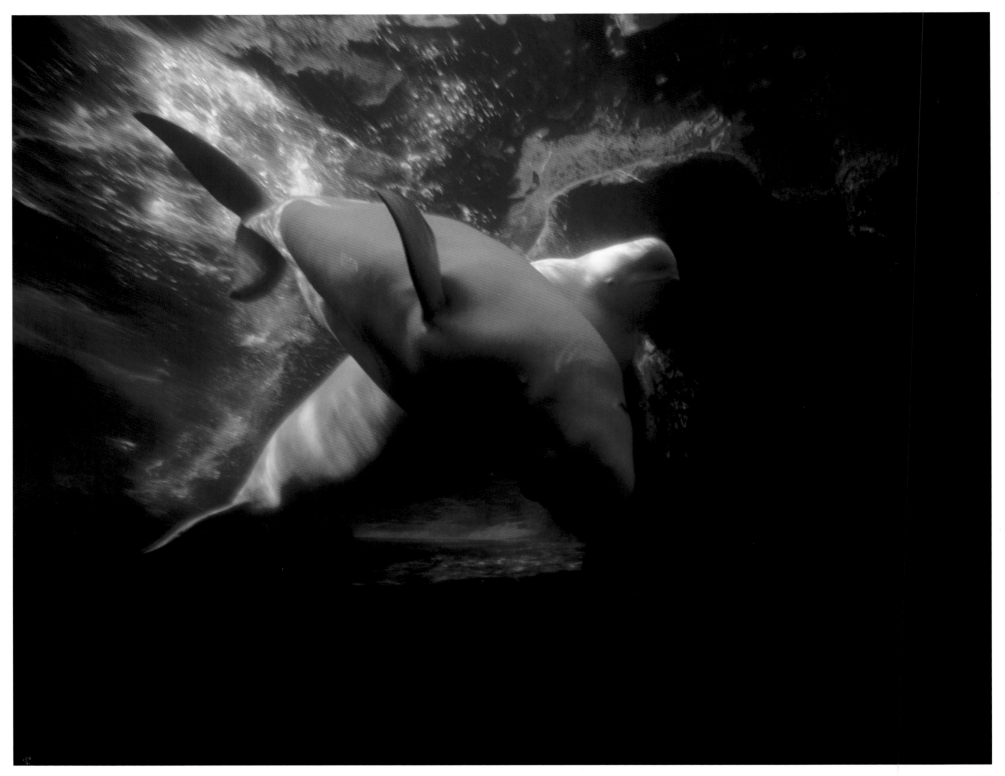

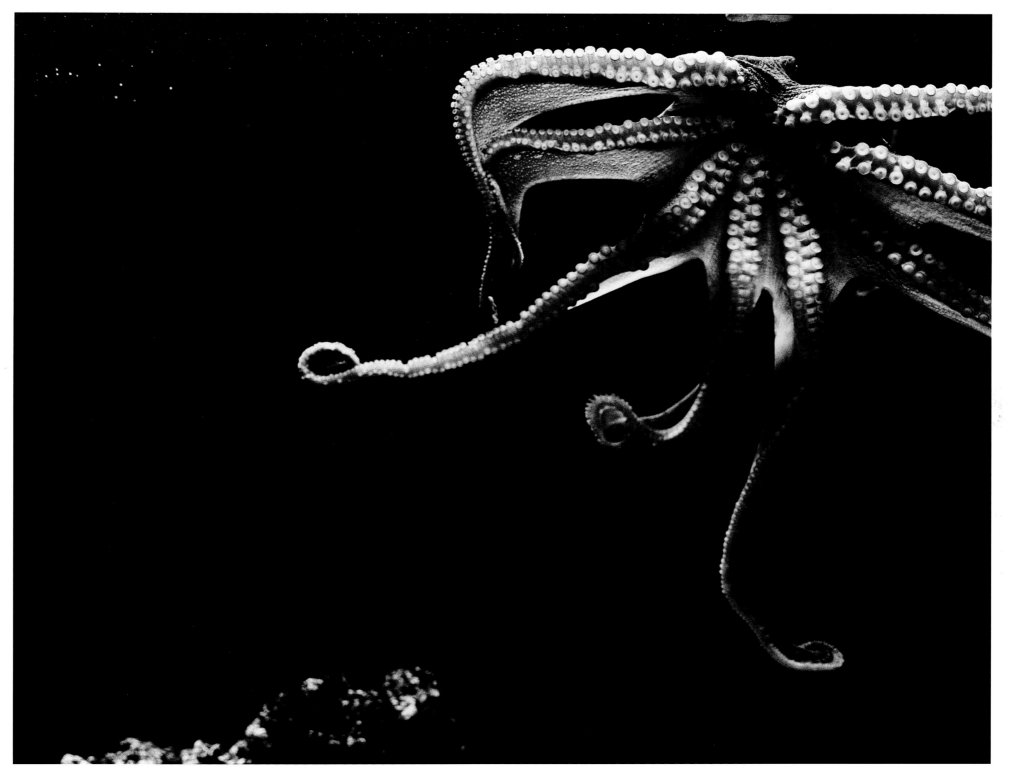

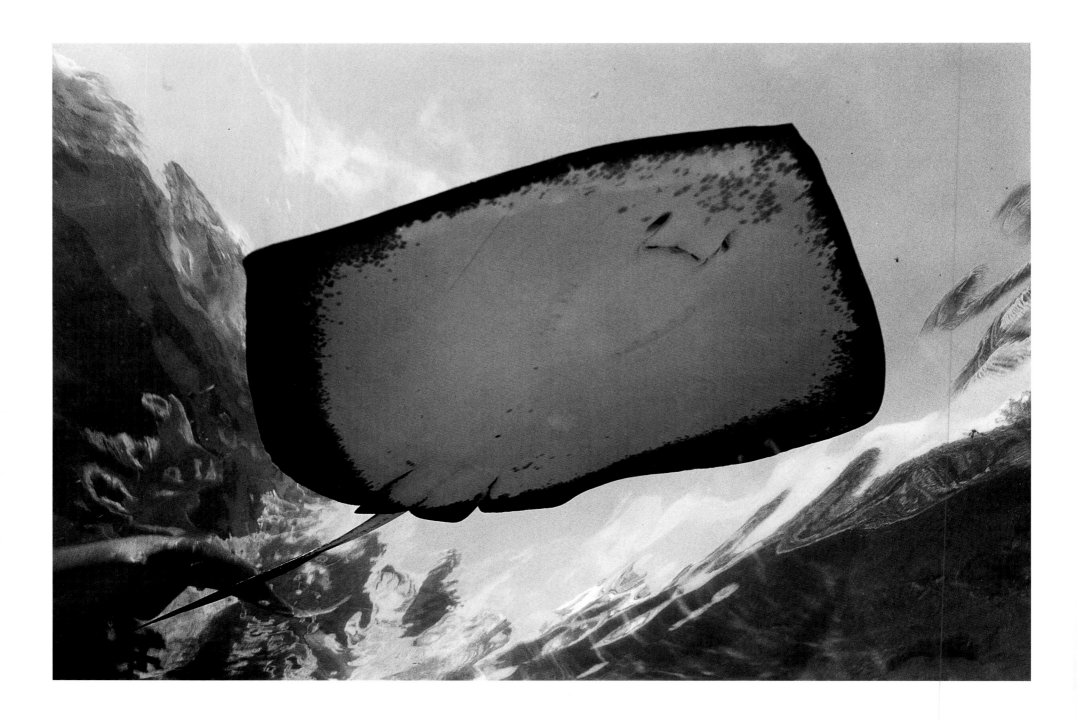

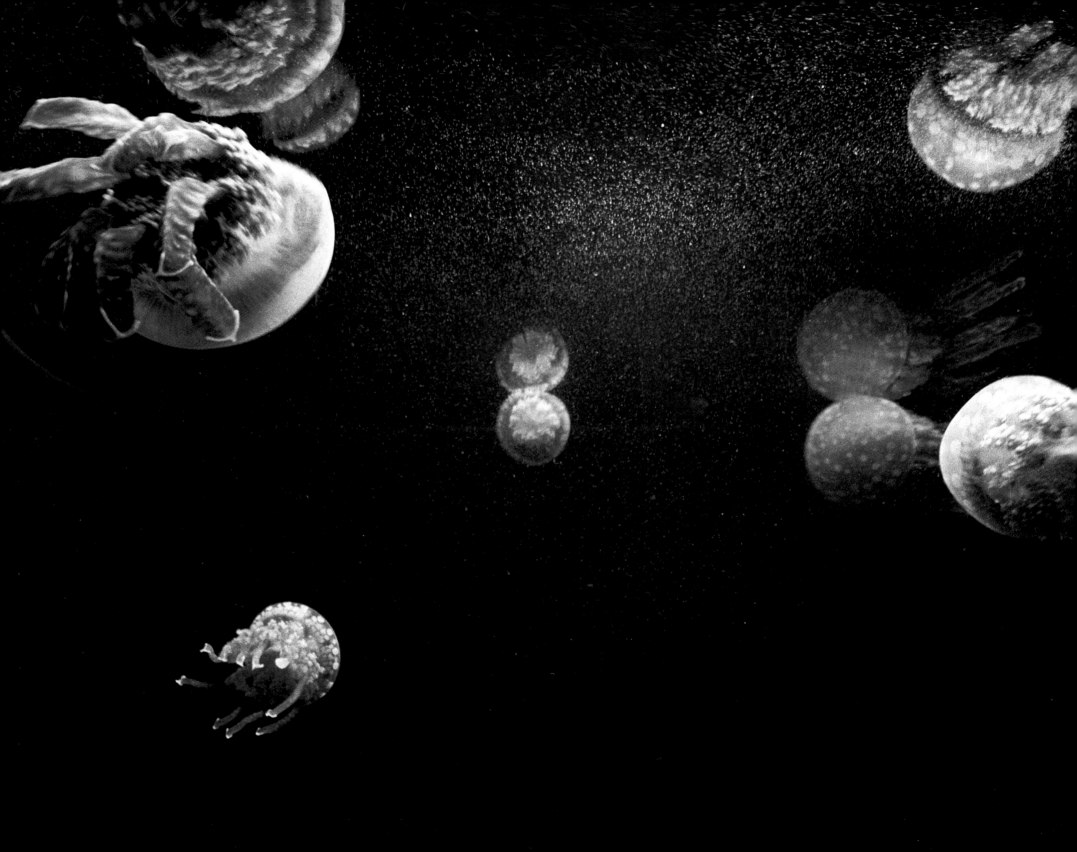

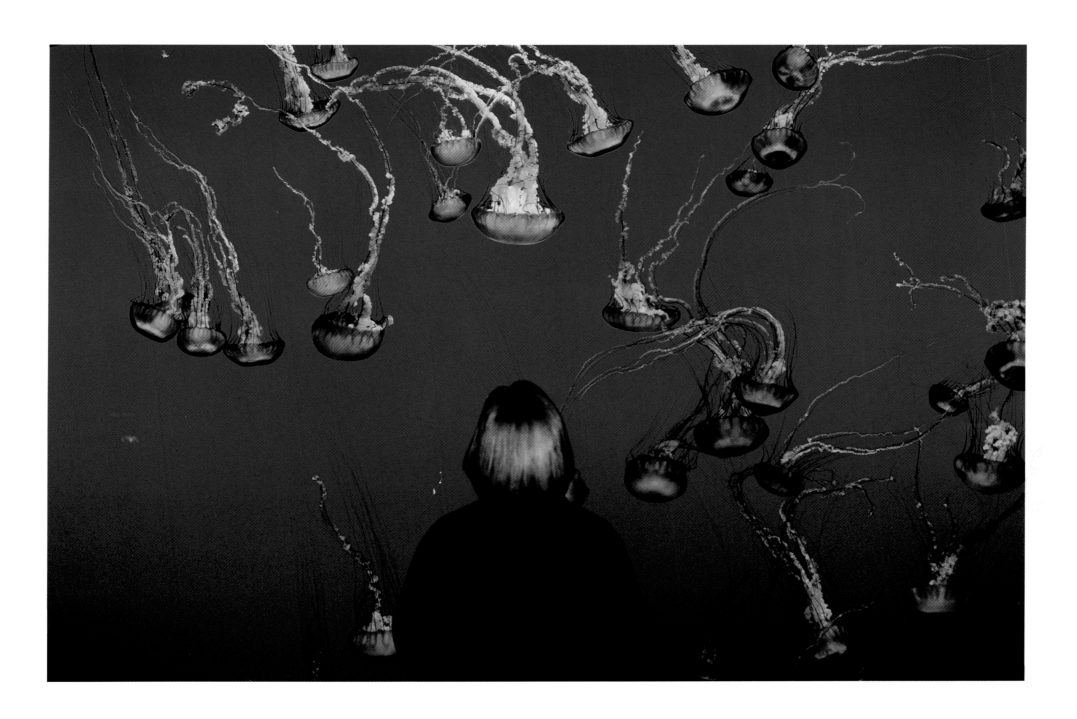

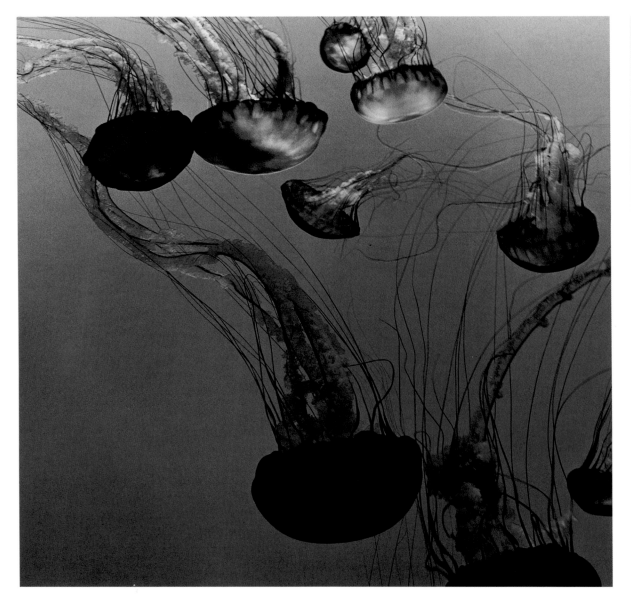
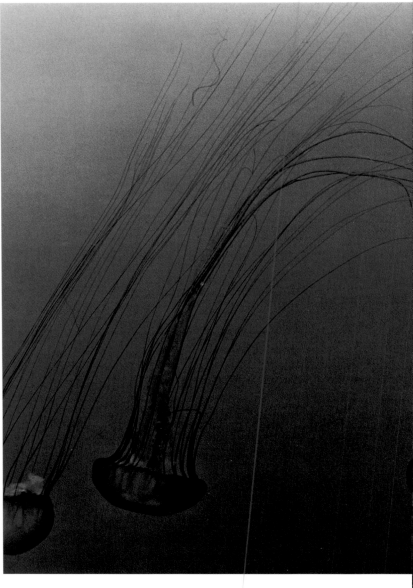

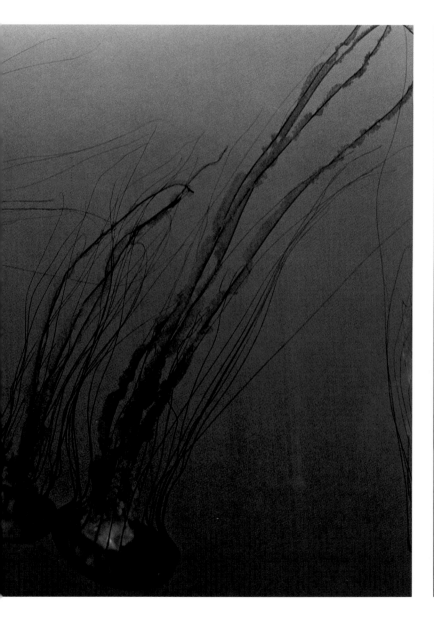
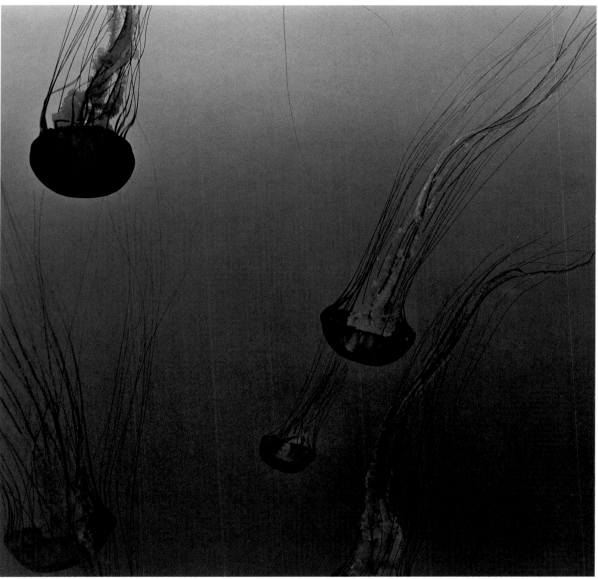

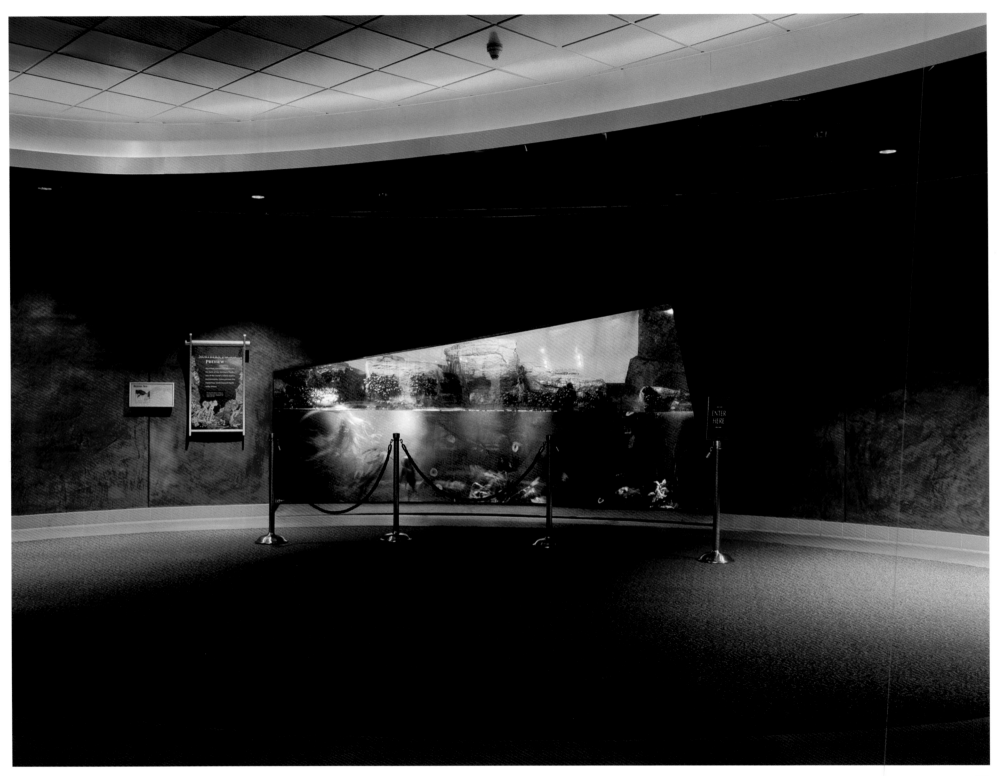

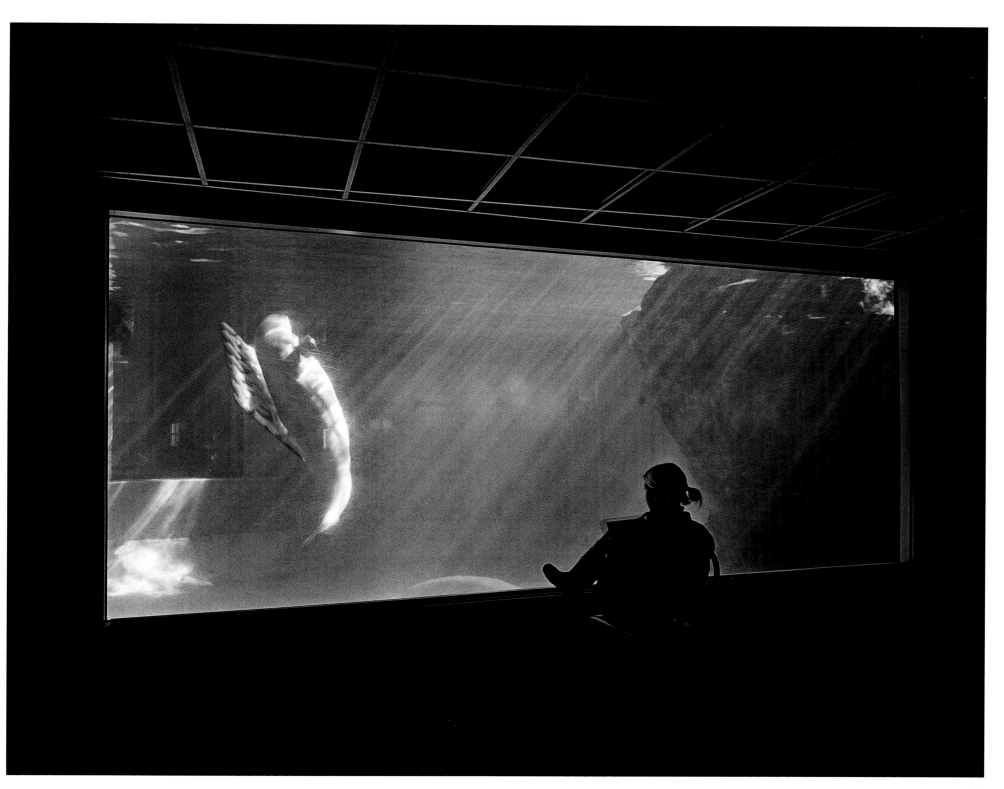

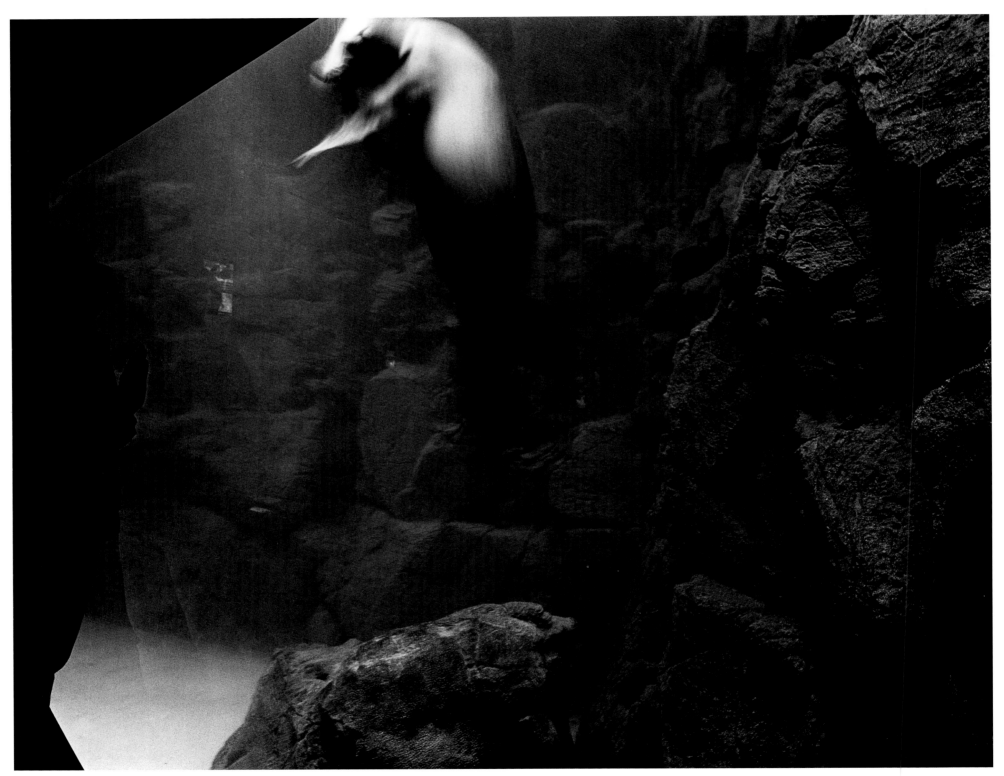

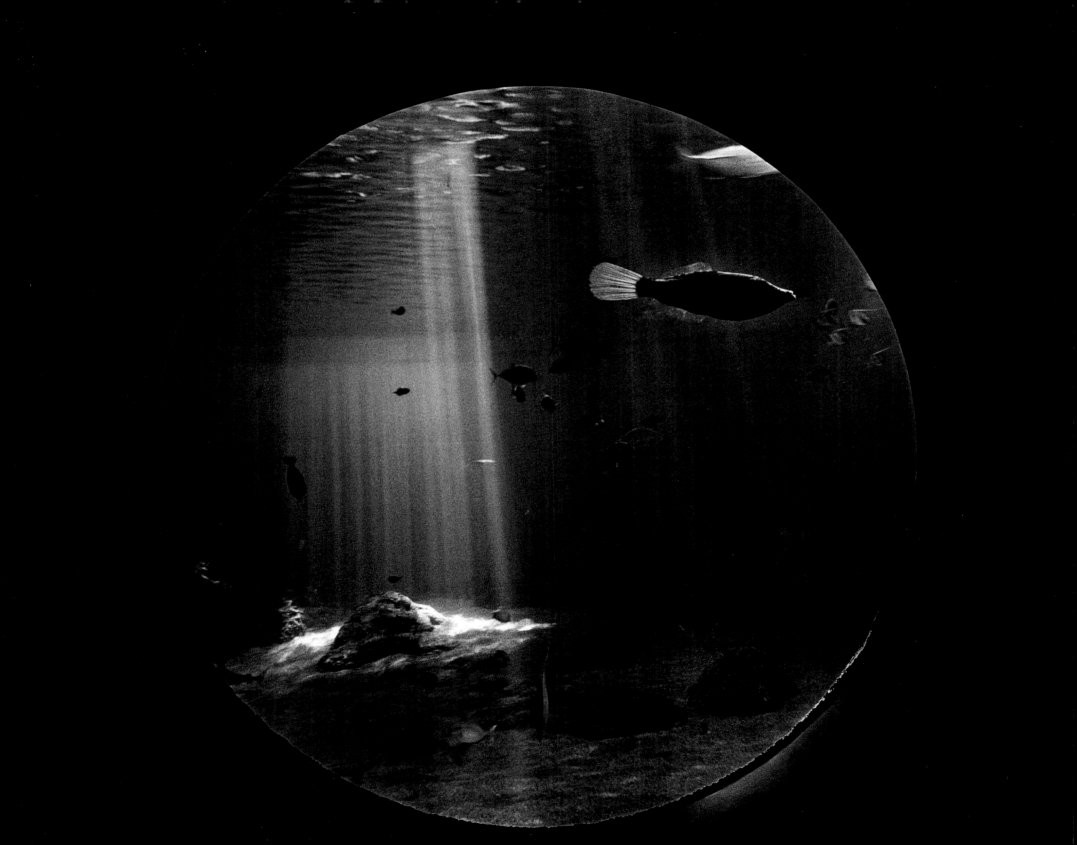

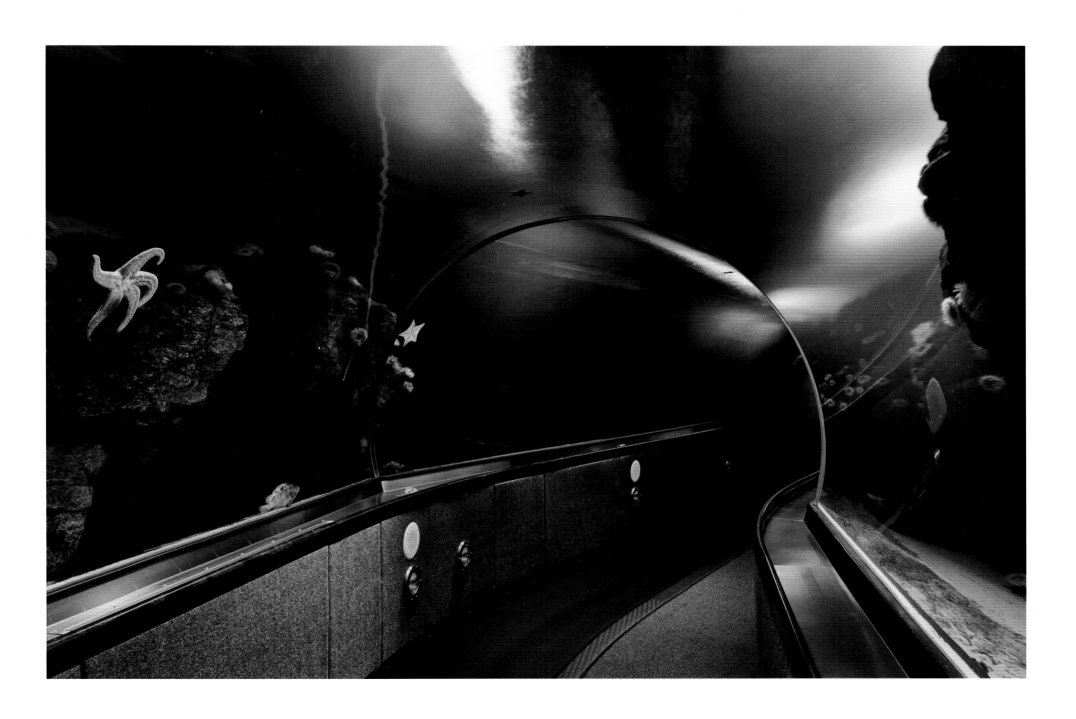

Lawrence Weschler: I first became aware of your work through two of your other projects – one completed and one, I believe, is still ongoing: volcanoes and icebergs – fire and ice, respectively. Where and how does *Aquarium* fit into the continuum of your work?

Diane Cook: Before beginning *Aquarium*, we worked on a project called *Hot Spots: America's Volcanic Landscape,* which was published in 1996. It was our first collaboration together. I was photographing in black-and-white and Len in color, and we were pairing our images on facing pages in the book. It was a project that dealt with the evidence of how the earth creates itself – and of the fragile human trace within, over, and against that astonishing process.

Len Jenshel: It was a traditional landscape project in concept, but with an untraditional formal twist – the pairing of work by two different people, and with that, two different mediums (color and black-and-white). [see figures A and B]

DC: Anyway, after *Hot Spots* was completed, we were thinking about doing another landscape project together, this time a meditation on water. We went out to California to do some work along the Pacific and in Yosemite. By chance, on our way back to San Francisco, we happened into a small aquarium – only spent a few hours there – and when we got home to New York, we were looking at the work from the trip. The pictures of crashing surf were okay, and the waterfalls were pretty ordinary, but it was the aquarium work that really struck a chord with us. Somehow that compression of ecology, a fantasy of landscape in this artificial and idealized place – those photographs

resonated with metaphor much more so than the photos from the natural world did.

LJ: To get back to your question about the continuum of our work: we have been landscape photographers for as long as we can remember – more than twenty-five years now. And although on the surface this project seems very different – an artificial landscape, for starters – it incorporates many of the themes and the threads of most of our prior projects, as well as our perceptions about landscape photography: namely the juncture of nature and culture, the idealization of beauty, the control of nature – and particularly in this project – the packaging of nature.

LW: And within that context, where does the ice work fit in? That's still an ongoing project?

LJ: Yes, we do work on several projects simultaneously. The work on one project overlaps and informs the other. So as we began this loosely defined project on water, we set off to explore water in its solid form – glaciers and icebergs. But ultimately the work itself defined the paths we took, and those paths diverged into aquariums and ice.

DC: That ongoing project – tentatively titled *On Ice* – is a meditation on the beauty of impermanence. And we'll see where it goes in this age of global warming.

LW: This may be a good place to ask about your background: who you are, where you come from, and how you came to photography. Presumably you weren't born photographers?

LJ: Far from it. In fact, I first studied chemical engineering in school, but that was short-

A B

lived. One day on the subway going to an organic chemistry class, I recall trying to pick up a woman, who just happened to ask the million-dollar question: what does a chemical engineer do? And when I could not answer her, I dropped out of the school that same day.

LW: Was that Diane?

LJ: No, it wasn't. And the funny part of this story is that this stranger changed my whole life, and I was too dumbfounded to even get her phone number. Anyway, I went back to school – art school, that is – in 1972, studying photography at Cooper Union in New York City with Garry Winogrand, Joel Meyerowitz, and Tod Papageorge. I graduated in 1975.

LW: Had *The Animals* already been published when you studied with Winogrand? I ask, of course, because I wonder about the extent to which Winogrand influenced this current body of work?

LJ: *The Animals* was published in 1969 – I knew the work very well – and it's interesting, this issue of influence. I studied with Winogrand in 1972 for a whole year, and like the rest of the class, we were all sort of copying his style: Leica, Tri-X, street photography. So after the first semester, Garry provoked the class by saying, "Let's do something crazy this next semester and shoot color transparency film." I accepted the challenge. I headed out with color film – still with a Leica and still on the streets – his influence was very strong in my student years – and then, the year after I graduated, I had this epiphany. I was at the 1976 bicentennial celebration kickoff in

Concord, Massachusetts. And after having photographed one parade too many, I finally was able to stop and say, "Boy, I hate this stuff! This is *not* who I am!" And so, similar to chemical engineering, I impulsively pitched the Leica for a medium-format camera, transparency film for negative film, and the streets for landscape. And over the next twenty years of my career, through many landscape projects, I had gone as far as one could go from Winogrand's style and technique. But when we started this aquarium project, I really felt his ghost staring over my shoulder. Sometimes while I was working, I would hear him saying things like, "And how is *that* different from what I did thirty years ago?" It was really weird, but I needed to acknowledge that issue, and ultimately, I think the work is different from what Garry did.

LW: How so? How is *Aquarium* different from *The Animals*?

LJ: Well, I think we're both interested in theater – that these places are stages for the dramas of life on both sides of the bars or glass. But I think *Aquarium* has more to do with people's obsession not only to collect and contain, but to neatly package nature. In addition, aquariums are very seductive places, they begin with the element of fantasy. I think our work is much more about the blurring of the boundary between the real and the unreal – and even the ideal – if you consider fantasy.

DC: Garry was looking at what both humans and animals were doing – with a razor-sharp eye. I think our work is more reflective; looking at what humans have built and the landscapes they create.

LW: So, getting back to your history, Len: it's 1976, and you've decided this is not what

you want to be doing. How did you make your way into what you did want to be doing?

LJ: I suppose it was color itself, in a strange way, that brought me to the land. It was color that nudged me toward the "eccentric" or "spectacular" landscape: like the strange and surreal formations of the desert southwest, for example. I was interested in the myth and how the automobile and tourism impacted the land.

LW: In the enterprise of sightseeing, as it were. Which is a nifty formulation when you think about it. People move around the country collecting predetermined vantages, "seeing the sights." And that body of work was partly about your watching them do that.

LJ: Yes, and that partly explains my obsession with the scenic overlook. But I also wanted to use color to accentuate this beauty, perhaps even exaggerate its seduction, almost to a theatrical point – which explains my fascination with using the car's headlights in *Travels in the American West.*

LW: Do you go out to the landscape with a preset agenda?

LJ: I try to work intuitively and spontaneously. I try to just be out there being challenged visually by things or ideas. Then comes this great surprise in the editing process, of seeing something new on the contact sheets. You see this image that screams out at you, and you can't believe you could have been the one who made it.

LW: As a writer, you quickly learn that editing isn't cleaning up after the party; editing *is* the party.

LJ: I like that.

LW: Well then Diane – what about you? What of your background?

DC: Well, I went to Douglas College, which is part of Rutgers University, where I was studying painting and art history. In my junior year, it occurred to me that I needed to figure out a way to earn a living when I left school and thus should learn a "skill" – like photography. But I instantly fell in love with the art of photography. When I graduated in 1976, I moved to New York City, and one of my first jobs was working as a photo researcher at a place called the Bettmann Archive.

LW: The great photo archive?

DC: Yes, and it was a fascinating place for me to be, because I was looking at all of these images of history, and looking at photos as evidence. When I was at Rutgers, there were a lot of conceptually based artists working there; so my first attempts at photography were about extending the frame and more conceptually-based issues about what a photograph is. I was not making single images or considering the poetry within the frame. It's interesting to look back and try to figure out what aspects of your life inform the artist you've become. Certainly when I think back to the time I was working at the archive, I see the shift in my sensibility to a love for that single image that conveys a precise observation.

Also, the Bettmann Archive was located near a lot of art galleries. At lunchtime I was going to photo galleries to look at shows. In addition to contemporary work, galleries were showing nineteenth-century imagery: Carleton Watkins, who I imme-

diately fell in love with. William Henry Jackson and Timothy O'Sullivan just blew me away. Spending a lot of time looking at nineteenth-century landscape photography definitely shaped my sensibility. So there was a wonderful connection between the "evidence" at the Archive, and the kind of "proof" in those nineteenth-century photographs.

LW: What do you mean by proof?

DC: I mean that literally. We forget that the camera was once a tool of truth. When the nineteenth-century photographers went out west, for example, they brought back proof of amazing stories of bubbling mud pots in Wyoming, and trees that were fifteen feet in diameter and 300 feet high in California. Until that documentation arrived back east, no one believed those tall tales, but the proof was in the photos. They were instrumental in convincing the government to create our first national parks.

LW: Were you yourself doing much photographing at this time?

DC: While working at Bettmann I took an evening class at the New School with Sean Kernan. He was a fantastic teacher. His way of teaching was about guiding students to find their true voice. Also, a fellow classmate introduced me to Len, so you might say a tangential bonus of that class was meeting Len Jenshel.

LW: So, when did you meet?

DC: We met in 1979, and were married in 1983.

LW: So at the time you met, were you photographing landscape as well?

DC: Yes, in a way. In 1980 I quit my job at the archive and took an extended photographic trip with Len. We went cross-country, mostly to the western national parks. I was mostly photographing people in the landscape, but was beginning my foray into a more traditional landscape.

LW: And you were doing it in black-and-white?

DC: Yes.

LW: Why black-and-white as opposed to color?

DC: I've always worked in black-and-white, for my personal work. I love that transformation and distillation provided by looking at the world with the color filtered out. When you look at a traditional color photograph, you are thrust into the "real" world. Whereas when you look at a black-and-white photograph, you get to distance yourself by taking a step back and looking at a scene or situation without the distraction, as it were, of reality. I love the idea of seeing the world more clearly through black-and-white.

LW: I would agree with you. I was thinking about this, looking at these pictures, and not valuing one over the other, but there is a sense in which there is more information in black-and-white than in color, because color is just like the world, whereas, oddly enough, when you say something is "in color," it's as if you've added something to it. Whereas, in fact, color is the thing that's the most ordinary, the most like the world itself, while black-and-white provides the real intensification of experience.

LW: So, now, flashing a bit more forward, can you describe the process behind these

extended projects of yours – *Hot Spots, Aquarium*. How do they come together?

LJ: Often, it is a single photograph that prompts us to take a certain path. When we see an idea in a photograph that excites us, it serves as a catalyst for a thought process about what kinds of pictures we want to make next and where we want to go to make those pictures.

DC: Another part of the process that we should probably mention is that we go off as individuals to make pictures. Working together does not necessarily mean that we are standing side by side. Some collaborators confer on every picture: think it out and discuss a strategy, even map out an exact frame. But we work independently of each other, trying to make the most interesting photographs we are capable of making. And it's only afterwards, in the editing, that – as you say – the party begins.

LW: What was it like working in aquariums?

LJ: Technically speaking, it is very challenging. It is often dark. We don't use strobe or hot lights, so four-second exposures are common. It can get very crowded, like the one day we had at the London Aquarium, which turned out to be on a bank holiday. Then there's the issue of reflections, though we try to incorporate them in an interesting fashion. And finally, fish that just won't cooperate: won't stand still, too fast or too shy, or in the wrong place at the wrong time – you name it. But, in the end, we try to embrace all of these challenges – reflection, weird light, blurs, and all. As we already said, we work intuitively and stay attuned to possibilities. We collaborate with each other, and with chance. Chance has a far greater imagination than we do.

DC: It is a great privilege to be an artist experiencing the world. Your work is the distillation of that experience, and hopefully, the work that comes out of that is something that will speak to other people – many people – and not just to yourself.

LW: Perhaps you can start again, tell the story of how this aquarium project actually began.

DC: Well, as we said earlier, the first place that we visited was an aquarium in San Francisco.

LW: Which one?

DC: It's called UnderWater World, a small aquarium in the Fisherman's Wharf area.

LW: Now, this was the first time you'd ever gone to an aquarium?

DC: Oh, no. My first recollection of visiting an aquarium was the Shedd Aquarium, which I had gone to when I was a child.

LW: In Chicago?

DC: In Chicago, right. That was the aquarium of my childhood when I was growing up in Indiana. The origins, though not the actual start of the project, go back to 1986. Len was teaching a workshop in Carmel, California, and I was out west with him. During the day, while he was teaching, I went off to photograph, and one day I happened into the Monterey Bay Aquarium. It's an amazing place. I was just blown away by the vicarious experience of being underwater. Anyway, I had my camera and tripod, and I took a couple of pictures there. They weren't fantastic photographs, but there was a photograph of a man standing in front of a dark tank, and it – the

102

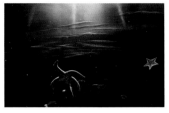
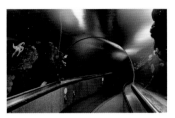

Page 4 Page 97

phenomenon, more than the picture – always haunted me: that there was this person who, through, I don't know, maybe a one-minute exposure, did not move at all – he appears totally sharp on the film. He was mesmerized. So, somehow, over the next decade, that photograph and experience stayed vivid in the back of my mind.

LW: You were mesmerized by the sight of this man who was mesmerized?

DC: Absolutely.

LW: And indeed, one of the things that happens in an aquarium is that you become mesmerized by the state of mesmerization.

So let's talk about those first two pictures in the current series, taken there at that small aquarium in San Francisco. And are those, by the way, the same starfish? [See pages 4 and 97]

LJ: It is indeed. Our photographs were made a few feet from each other, but they couldn't be more different. Diane's picture is so lyrical. It is a total transformation in which water becomes sky. The blurred streaks of fish seem to resemble cirrus clouds, the streaks of light become rays of the sun, and stars (or starfish) dance across the sky. I guess it's a transformation from liquid to gas – everything that is underwater suddenly rendered as heavenly.

DC: And Len's photograph is pure mystery – looking into the mouth of the tunnel – it lures you on into, into what? We don't know.

LW: And it's as if the starfish is waving good-bye. Looking at those two images reminds me how every photograph ever taken, in a certain sense, makes an aquarium of the world. I mean, a photograph is like a pane of glass put over the world.

DC: Absolutely.

LW: There's a flat surface beyond which the world appears. So that when you're photographing aquariums, there's a doubling kind of process.

LJ: I agree. The aquarium window possesses a remarkable resemblance to the photographic image – both being windows into discoveries and the unknown. There is yet another parallel experience between photography and aquariums – and that is the notion of collecting. Historically, photography made the larger visual world collectible. Aquariums collect some pretty strange creatures as well, and show us a world that we wouldn't normally encounter in our daily lives. Out of that collecting comes awareness.

DC: Also, a major part of the evolution of aquariums had to do with the development of inexpensive and durable glass or plastic. It's that window that allows us the privilege of peering below the surface into this mysterious and seductive world.

LW: Well, you'd clearly begun dealing with a lot of issues, but when did this really take off and become a project?

DC: A year after stumbling into that small aquarium in 1997, we were back in California and went to the Monterey Bay Aquarium. It was that second venture into those crazy worlds that really got the project off the ground for us. It was the combination

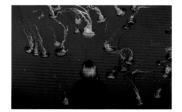

Page 87

of two things that sealed this as a project. One, it was a fabulous place – and confirmed that aquariums would be interesting places to work – and two, we both made a really good picture from there.

LW: Which pictures are from Monterey?

LJ: The photograph of the woman staring into the jellyfish tank. [see page 87]

LW: The jellyhead and the jellyfish, as I think of them?

DC: That tank constitutes one of the most seductive exhibits in Monterey. And this photograph starts with a similar notion of seduction – first in the way the photo draws you into it by virtue of the colors and jewel-like jellies and, in terms of its subject, the way this woman is captivated by the slow-motion show in front of her. It is also about boundaries. First, the dissolving of them, wherein the woman's hair becomes one more golden blurred floating jellyfish-like shape – what does it mean to morph into the jellies? – and also in the sense that the Plexiglas between the two worlds separates the terrors and pleasures of their side from the security and comfort of ours. What is so odd about the popularity of these displays is that if you ever encounter jellyfish in the real world, you bolt: a very curious piece of human behavior. But, getting back to the notion of seduction, I think the real subject of this photo is astonishment and wonder.

LW: This reminds me of an essential difference between zoos and aquaria, and hence as well between Winogrand's world and yours. Even independent of photography, the experience of going to a zoo is very much an experience of projecting and anthro-

pomorphizing, such that one finds oneself thinking, for example, "Oh, I know exactly what it's like to be hassled by your boss, just like that monkey is being," or "That rhino is so lazy," or "It must be fun to be stomping around in the dust like that elephant." There's all that kind of projection onto the animals as fellow creatures, and Winogrand, of course, is deep into that as a subject. Whereas in an aquarium, my own experience, and certainly, it seems to me, yours as well (at least as I experience it in that photograph) is that you don't identify with fish or even jellyfish as other individuals, as other subjects or other selves like oneself. Rather, the way you identify with them is almost as *thoughts*.

They're floating. Sometimes, you will identify with a whole school of fish, but generally you don't fixate on a particular fish. And in this sense, what a jellyfish tank looks like to me is, it looks like daydreaming.

DC: There is that, but the writer Eliot Weinberger gives us another way to consider this. In his essay "The Laughing Fish," he writes, "To watch fish is to not be oneself…. A fish neither reflects nor questions our existence. A fish is and we are: to become engrossed in watching fish is to forget that we are, but without, as mystics experience, becoming part of what we observe."

LJ: The problem in aquariums with having a moment of tranquil observation requires one to filter out the noise and distractions of others. I think that Diane gives us that moment with her photograph from Monterey – the jellyfish triptych. Actually, to be specific, these creatures in both our photos are sea nettles, and they do float upside

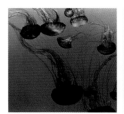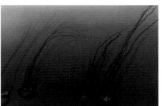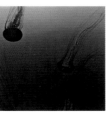

Pages 88-89

down. [see pages 88 and 89]

LW: That's a marvelous piece.

DC: It was very exciting to put these three panels together. I love Japanese scroll paintings, and the idea that I could create a photograph that might touch upon some of that elegance, the unfolding over time – I wanted to explore that possibility.

LW: Were you doing it as a triptych as you were taking it?

DC: No, actually, it was something that occurred to me when I was looking at the proof sheets. I was photographing the tank over a period of time, and somehow, I couldn't get the totality of my experience into just one frame. And the way to do it, for me, was to put the three frames together.

LW: How many pictures were there, all together, out of which you drew those?

DC: I'm guessing maybe twenty.

LW: The other thing with the triptych structure is that it reminds one of the quality of a tank with panes of glass separated by bars. It's as if you were standing in front of the middle panel of a wide tank and looking to one side and then the other.

DC: Yes, and another reference, for me, is the portable altarpieces that people took on their travels in medieval times. As such, the experience of being at an aquarium, or hopefully from looking into this photograph, affords a new way of meditating and clearing our minds.

LW: Another association with the medieval altarpiece, which is absolutely one of the things I think of, is of angels come down to earth. Annunciation is a phrase that comes to my mind. And again that is a frequent experience visiting an aquarium, again, as opposed to a zoo. It can get prayerful, as it were. By contrast, you don't get into that kind of meditative mood when gazing into a chimpanzee cage, where the experience is more about sociology or intersubjectivity. I don't want to press the point too far, but a jellyfish tank feels the way the mind swims. Now, for all I know, jellyfish are hugely intelligent creatures.

DC: Well, the truly intelligent creatures, at least as we heard, are the octopi. They're amazingly intelligent.

LW: How so?

DC: Well, there are many stories about octopi in aquariums, but one in particular stands out. At three different aquariums, we basically heard this same story, or slight variations on it. We were told that when the marine biologists would come in to check the tanks in the morning – now this would be the behind the scenes – they would walk in and see all these fish bones and crab legs scattered all over the floor.

LW: The dry floor?

DC: Yes, all over the dry floor. And they were trying to figure out how these things were being eaten, and why they were being left on the floor. Was there a cat on the loose? So they set up a night watchman to observe the tanks at night, after everyone had gone home. The next morning, there was nothing out of the ordinary to report.

LJ: This scenario goes on for a whole week.

DC: So, they said, "Okay, well, whatever it was, it's not here anymore." They went back

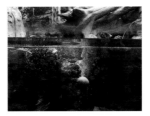

Page 69

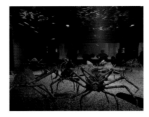

Page 39

to life as normal: no night watchman. The next day, they walked in: fish bones, crab legs all over the floor. So, finally, they decided to set up a video camera. The next morning, they watched the video and saw the octopus squeezing itself out of a tiny one-inch hole in its tank, crawling across the floor, going into the other tanks and eating its fill.

LW: Of fish that were in the other tanks?

DC: Yes, and then somehow knowing to get back to its tank an hour or so before the first morning arrivals.

LJ: So there was no trail of water across the floor – absolutely no evidence.

DC: And I just thought, these creatures are totally brilliant.

LJ: Since hearing this, Diane can no longer eat octopus.

LW: How long did this project take once you really got going on it?

DC: A little over three years.

LW: So you had a unique experience of going to dozens of aquariums in a concentrated period of time.

LJ: It *has* been a great privilege to see so many different aquariums over the last three years. Every one, in its own unique way, has something that no other aquarium offers. So whether it's the ones with the huge tanks in Monterey or Lisbon that offer one the illusion of being underwater, or the smaller ones like the Waikiki Aquarium that grow coral – and actually supply live coral to other aquariums. They all

afford wonderful and memorable experiences.

And then there are the unexpected exhibits like Sumatran tigers diving for pumpkins in the Denver Aquarium [see page 69], and giant spider crabs in the tanks in Osaka, Japan. [see page 39]

LW: You mean the one that I think of as the Star Wars picture?

LJ: I was actually thinking about that movie the entire time I was making that picture.

LW: Crab Troopers!

LJ: And we both adore the Monterey Bay Aquarium.

DC: Vancouver is another aquarium which we found fascinating. Actually, after we were finished photographing there, they allowed us to go into the tank with the beluga whales. It was so terribly exciting for me, being allowed to touch this animal and interact with it, that I absolutely forgot what I was doing, forgot that I had film in my pockets, and I had waded into the water up to my waist. Luckily, the film was in zip-lock bags and wasn't ruined. Nothing like getting a little carried away.

LW: It's interesting, by the way, with aquariums; generally they're dark. And it's dark underwater, by definition. So it can get similar to the cinema in that sense of being in a dream state. With everybody in a room together, it's like you're in a public dream, in some sense.

LJ: Yes, that idea is evident in one of our pairings – the color photograph of the display case that is roped off, with the black-and-white photo of the woman seated in front

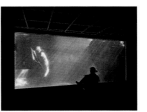

Page 91

of a large window looking at a beluga whale. [see pages 90 and 91]

When we put pictures together, we want them to inform each other. So you have this velvet rope in the color picture, a reference to a theater lobby, and the black-and-white photograph – which not only captures the contemplative experience of aquariums, but also shows on this metaphorical picture screen, a Beluga appearing to have sprouted wings.

DC: We love this metaphor of theater – where the glass is a curtain, the aquarium is the stage, and the drama is acted out on both sides of the glass.

LW: Let's talk about certain other themes that run through the whole book. For me, one of them you highlight at the beginning of the book with that Einstein quote about wonder.

> "The most beautiful experience we can have is the mysterious. It is the fundamental emotion which stands at the cradle of true art and true science. Whoever does not know it can no longer wonder, no longer marvel, is as good as dead, and his eyes are dimmed."

So, clearly one of the things that this book is about is that moment of marvel, what I call the "pillow of air" moment, where your mouth falls open, and there's this pillow of air that gets lodged in it, that moment of rapt stillness. This is partly the sort of experience that comes over you when you're in the aquarium itself, but it also comes when you're looking at many of these pictures. In literal terms, it's the expe-rience that you capture with the picture of the woman looking at the jellyfish.

LJ: Right.

LW: The moment when you are lost to yourself, when you are given over to the wonder. That's clearly one of the things going on.

LJ: Sure, the fundamental issue with wonder – and I think you capture it beautifully in your book, *Mr. Wilson's Cabinet of Wonder* – is this notion of creativity arising out of astonishment and absorption. It is fundamental to what we've tried to do in this work, the wonderment of that fantastic, seductive world.

LW: "Seductive," of course, is a loaded word in this context, because it also has a quality of P. T. Barnum hucksterism to it. We might want to distinguish between those two because some of the places you visited have a P. T. Barnum quality to them, and some of them don't.

DC: I would say that most do not – although we should give P. T. Barnum credit – he did introduce aquariums to America.

LW: There is another strain running through here, which is what I might call "the goofy," and whereas in Winogrand such a strain often verges on the almost harsh and sarcastic and in-your-face, with you it's more gentle, there's more of a "Oh, what fools these mortals be" tone to it.

Such that instead of calling this book *Animals,* in the sense of there being animals on both sides of the cage, you could have called it *Mortals* – "mortals" in that Midsummer Night's Dream sense of the word, the foolish-goofy sense. You see it in some of

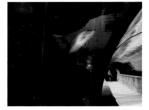

Page 48

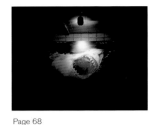

Page 68

Page 27

these pictures: for example, the mermaid [see page 21], but not just her. Or rather, it's as if the mermaid, the lady playing her, presently gets out of the water and dons her short hotpants and saunters on out toward the tunnel in the other image [see page 48]. I know it's not the same lady, but the two images have the same goofy tenor, I think the latter is a hilarious picture. Is that fair, though? Is "goofy" a good word? Or don't you like it?

DC: I think of it more as humor, which is certainly a big part of the work. As in the photograph of the great white shark with its mouth gaping open [see page 68] – at first it looks terrifying. But then you look at it and say, "Hey, wait a minute, is that real?" When you realize it's a poster, fear becomes funny. I'm sure it was a slightly goofy impulse that was behind Len's having made that photograph.

LW: Then, there's another strain that runs through the book, the one that goes, "Wait a second, this is not the ocean: these animals are in a kind of prison."

DC: That's right.

LJ: Diane touches on that issue in the photograph from the National Aquarium in Washington, D.C. [see page 27]

DC: It's one of the oldest aquariums in this country. And it's in the basement of the Commerce Building, which is an interesting comment, in and of itself: how our government thinks of nature as something that is commerce, and it only belongs in the basement.

LW: It's even *beneath* commerce!

LJ: Exactly. Anyway, the fish appears to be in solitary confinement, if I may anthropomorphize a bit.

LW: So that the book reads in all of these different ways: there's the pillow of air, the marvel and the wonder; there's a humor that at times verges on the almost slaphappy; there's the meditative and the prayerful; there's the theatrical, and then there's this pang, this tinge of pity, the horror.

And then there's the book as a whole, how we experience the procession of images as distinct from the individual photographs, and there the experience is one of an overarching intelligence, or rather a pair of them engaged in a dialogue whose principal quality is one of – I guess you could say: wit – the kind of editing process wherein you've managed to put all those interesting aspects side by side, one after the next. I mean, for example, let's take one of the first such pairings in the book – the somersaulting crab and the crablike somersaulting kids in front of the big tank. [see pages 14 and 15]

One long, extended somersault of wonder and delight vaulting from the one image to the next. When I came upon that pairing the first time, I suddenly realized, "Oh, wait, it's going to be that kind of book. There's going to be a play of intelligence across this body of work, such that moving through this volume, it's going to pay to keep paying attention and remaining open to the wit of it, that there's going to be this whole other layer that's layered on top of things: how whenever there are two pictures side by side, there's likely to be some reason they're side by side."

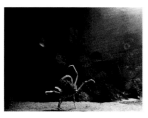 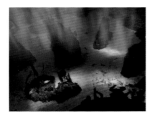

Page 14 Page 15

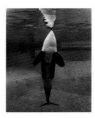 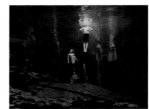

Page 20 Page 21

Let's talk about one of the other pairings. Do you have a favorite?

LJ: One comes to mind toward the beginning of the book. It is the picture of Diane's of an orca whale and my picture of that mermaid show. [see pages 20 and 21]

DC: These mermaid shows have actually been going on for decades. The inspiration for going to Weeki Wachee Springs in Florida came from these postcards we have from the 1950s, of a mermaid drinking from a bottle of Coca-Cola underwater.

LW: What's so funny for me about that pair is that it looks like the guy next to the mermaid has just barged in and is totally out of his depth, totally awkward. And opposite that picture is the tuxedoed whale, dressed to the nines. That guy is just so oafish, and the whale is looking really cool. The real match between those two pictures is that between the whale and guy.

LJ: And for me, the dialogue between these two pictures is about theater – one literal, a performance of "The Little Mermaid," and one metaphorical, the whale in a tux taking his bow.

LW: Where was the whale, by the way?

DC: That's in Vancouver, Canada. I don't believe that orca is at the Vancouver Aquarium anymore. Orcas are very social animals, and the marine biologist there felt it needed to be with a group, and it was being shipped out to another aquarium. So, it was both literally and metaphorically taking its last bow.

LW: So, what have you got coming up? What's next?

DC: We're still working on the ice project. In addition to that, we received a fellowship last year from the Design Trust for Public Space that helped us launch a project that we are working on closer to home. The working title is, "On The Edge: The New York City Waterfront." We are looking at that defining edge of New York City where nature ends and human-made structures begin. We continue to be fascinated with that meeting point of culture and nature.

LW: Except, of course, for the obvious fact that the distinction between nature and culture is illusory. We are just animals, too. And we are of nature.

LJ: That's true.

LW: Except, maybe, that one way of defining man, or human beings, as distinct from the rest of nature, is that we are the only creature who imagine ourselves to be distinct from the rest of nature. And that, in and of itself, is pretty comical.

DC: Yes, and I guess it's ironic that we humans, who think of ourselves as being separate from nature, are the ones who try to create these artificial and perfect worlds. I'm sure some would like to think that aquariums are perfected universes, but when you look at some of these pictures, you see peeling paint and crumbling tanks.

LW: The dilapidation of perfection.

DC: Exactly, and another undercurrent in the work is that what you don't take care of falls apart. The world needs tending.

INDEX TO THE PHOTOGRAPHS

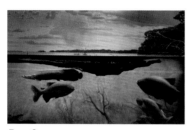
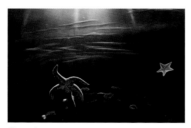
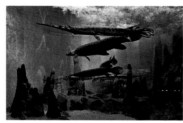
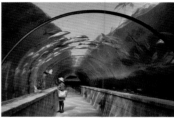
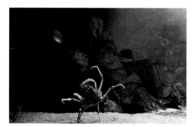
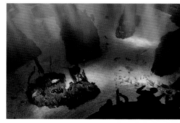
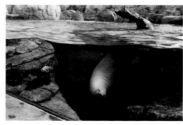
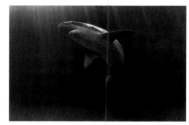
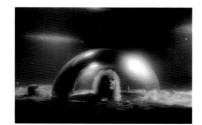
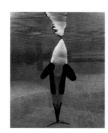
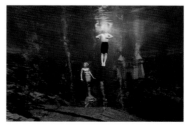
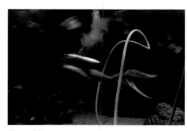

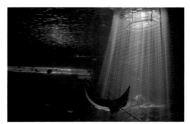

Page 23
Maui Ocean Center, Maʻalaea, Hawaii

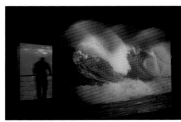

Page 25
Vancouver Aquarium, Vancouver, Canada

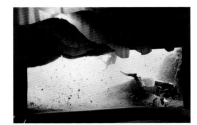

Page 26
Lisbon Oceanarium, Lisbon, Portugal

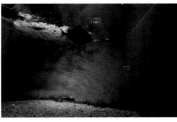

Page 27
National Aquarium, Washington, D.C.

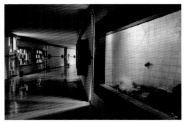

Page 29
Aquarium, Lenin Park, Havana, Cuba

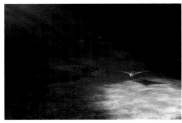

Page 30
Maui Ocean Center, Maalaea, Hawaii

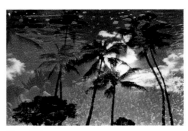

Page 31
Aquarium for Wildlife Conservation,
Brooklyn, New York

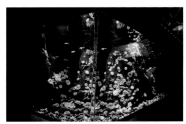

Page 33
Waikiki Aquarium, Honolulu, Hawaii

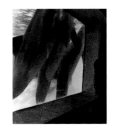

Page 34
National Aquarium, Havana, Cuba

Page 35
Atlantis, Paradise Island, Bahamas

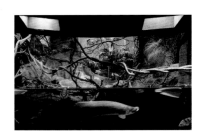

Page 36
Kaiyukan Aquarium, Osaka, Japan

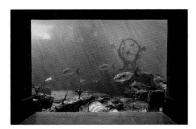

Page 37
Atlantis, Paradise Island, Bahamas

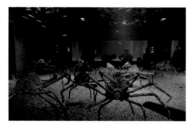

Page 39
Kaiyukan Aquarium, Osaka, Japan

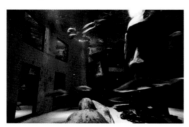

Page 40
London Aquarium, London, England

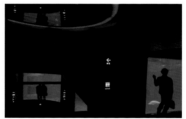

Page 41
Kaiyukan Aquarium, Osaka, Japan

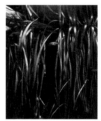

Page 42
Leipzig Aquarium, Leipzig, Germany

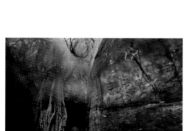

Page 43
Colorado's Ocean Journey, Denver, Colorado

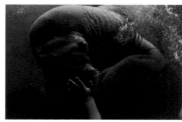

Page 45
Aquarium for Wildlife Conservation,
Brooklyn, New York

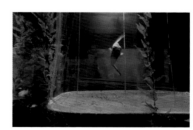

Page 46
Kaiyukan Aquarium, Osaka, Japan

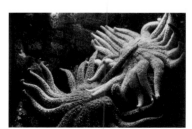

Page 47
Oregon Coast Aquarium, Newport, Oregon

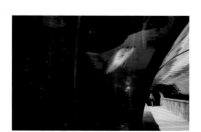

Page 48
Atlantis, Paradise Island, Bahamas

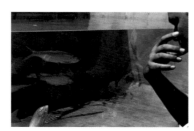

Page 49
National Aquarium, Havana, Cuba

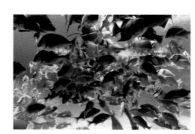

Page 51
Atlantis, Paradise Island, Bahamas

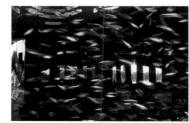

Page 52
National Aquarium in Baltimore,
Baltimore, Maryland

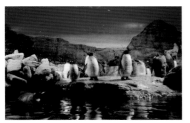

Page 53
Kaiyukan Aquarium, Osaka, Japan

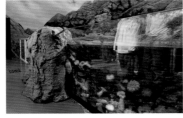

Page 55
Lisbon Oceanarium, Lisbon, Portugal

Pages 56-57
Oregon Coast Aquarium, Newport, Oregon

Page 59
Aquarium, Lenin Park, Havana, Cuba

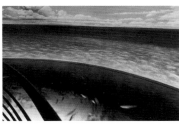

Page 60
National Aquarium in Baltimore,
Baltimore, Maryland

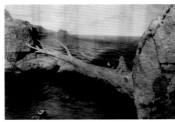

Page 61
Lisbon Oceanarium, Lisbon, Portugal

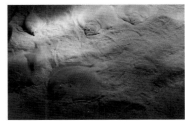

Page 63
Lisbon Oceanarium, Lisbon, Portugal

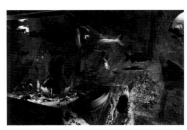

Page 64
London Aquarium, London, England

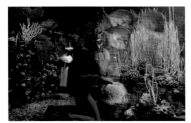

Page 65
Long Beach Aquarium of the Pacific,
Long Beach, California

Page 66
John G. Shedd Aquarium, Chicago, Illinois

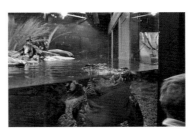

Page 67
New England Aquarium,
Boston, Massachusetts

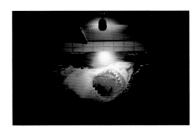

Page 68
Florida Aquarium, Tampa, Florida

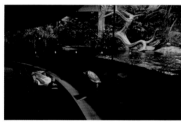

Page 69
Colorado's Ocean Journey, Denver, Colorado

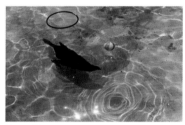

Page 71
Vancouver Aquarium, Vancouver, Canada

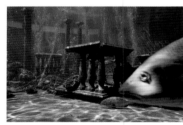

Page 72
Oregon Coast Aquarium, Newport, Oregon

Page 73
Port of Nagoya Aquarium, Nagoya, Japan

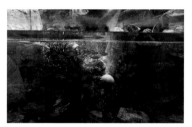

Page 74
Port of Nagoya Aquarium, Nagoya, Japan

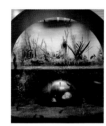

Page 75
Atlantis, Paradise Island, Bahamas

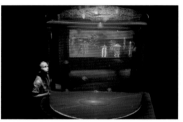

Page 76
National Aquarium, Havana, Cuba

Page 77
Miami Seaquarium, Miami, Florida

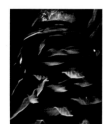

Page 79
Florida Aquarium, Tampa, Florida

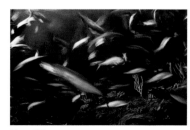

Page 80
Florida Aquarium, Tampa, Florida

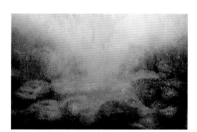

Page 81
New England Aquarium,
Boston, Massachusetts

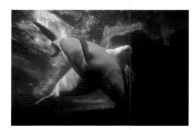

Page 82
Vancouver Aquarium, Vancouver, Canada

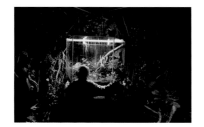

Page 83
Waikiki Aquarium, Honolulu, Hawaii

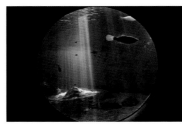

Page 84
Atlantis, Paradise Island, Bahamas

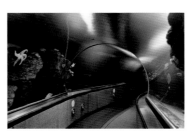

Page 85
Waikiki Aquarium, Honolulu, Hawaii

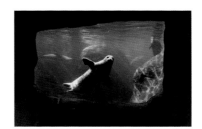

Page 87
Monterey Bay Aquarium, Monterey, California

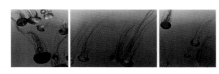

Pages 88-89
Monterey Bay Aquarium, Monterey, California

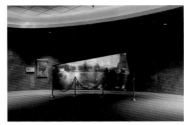

Page 90
Long Beach Aquarium of the Pacific,
Long Beach, California

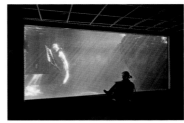

Page 91
John G. Shedd Aquarium, Chicago, Illinois

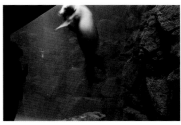

Page 92
Kaiyukan Aquarium, Osaka, Japan

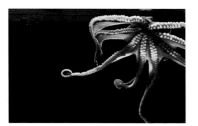

Page 93
London Aquarium, London, England

Page 95
Maui Ocean Center, Ma'alaea, Hawaii

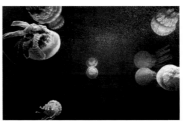

Page 97
UnderWater World, San Francisco, California

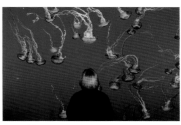

Page 119
Oregon Coast Aquarium, Newport, Oregon

AQUARIUM LISTINGS

Aquarium for Wildlife Conservation

(Coney Island)

Surf Avenue and West 8th Street

Brooklyn, NY 11224

(718) 265-FISH

www.nyaquarium.com

Aquarium of the Bay

(formerly UnderWater World)

Pier 39, Fisherman's Wharf

San Francisco, CA 94133

(888) SEA-DIVE

www.aquariumofthebay.com

Atlantis

(Paradise Island)

PO Box N-4777

Nassau, Bahamas

(242) 363-3000

www.atlantis.com

Colorado's Ocean Journey

700 Water Street

Qwest Park

Denver, CO 80211

(888) 561-4450

www.oceanjourney.com

Crystal Cay Marine Park

West Bay Street

Nassau, Bahamas

(242) 328-1036

The Florida Aquarium

701 Channelside Drive

Tampa, FL 33602

(813) 273-4000

www.flaquarium.net

Havana Aquarium

Lenin Park, Arroyo Naranjo

Havana, Cuba

John G. Shedd Aquarium

1200 South Lake Shore Drive

Chicago, IL 60605

(312) 939-2435

www.sheddnet.org

Kaiyukan (Osaka Aquarium)

Tempozan Harbor Village

Osaka City, Japan

+81 6 6576 5501

www.kaiyukan.com

Leipzig Zoological Garden

Pfaffendorfer Strasse 29

Leipzig 04105

BRD-O7010, Germany

+49 34 1593 3500

Lisbon Oceanarium

Esplanada D. Carlos I - Doca dos Olivias

Lisbon, Portugal

21-891-7002

www.oceanario.pt

London Aquarium

County Hall

Westminster Bridge Road

London, SE1 7PB, UK

+44 (0) 20 7967 8000

www.londonaquarium.co.uk

Long Beach Aquarium of the Pacific

100 Aquarium Way

Long Beach, CA 90802

(562) 590-3100

www.aquariumofpacific.org

Maui Ocean Center

192 Ma'alaea Road

Ma'alaea, Maui, HI 96793

(808) 270-7000

www.mauioceancenter.com

Miami Seaquarium

4400 Rickenbacker Causeway

Miami, FL 33149

(305) 361-5706

www.miamiseaquarium.com

Monterey Bay Aquarium

886 Cannery Row

Monterey, CA 93940

(831) 648-4800

www.mbayaq.org

The National Aquarium

Department of Commerce Building,

Room B-077

14th Street and Constitution Avenue, NW

Washington, D.C. 20230

(202) 482-2825

www.nationalaquarium.com

National Aquarium in Baltimore

Pier 3, 501 East Pratt Street

Baltimore, MD 21202

(410) 576-3880

www.aqua.org

National Aquarium of Cuba

Avenida 3ra, Esquina 62

Havana, Cuba

(53-7) 29-3504

www.acuarionacional.cu

New England Aquarium

Central Wharf

Boston, MA 02110

(617) 973-5200

www.neaq.org

Oregon Coast Aquarium

2820 S.E. Ferry Slip Road

Newport, OR 97365

(541) 867-FISH

www.aquarium.org

Port of Nagoya Public Aquarium

1-3 Minato-cho

Minato-ku

Nagoya, Aichi 455-0033, Japan

+81 (0)520 654 7080

Vancouver Aquarium

Stanley Park

Vancouver, BC, Canada V6B 3X8

(604) 659-3474

www.vanaqua.org

The Waikiki Aquarium

Manoa 2777 Kalakaua Ave.

Honolulu, HI 96815

(808) 923-9741

www.waquarium.otted.hawaii.edu

Weeki Wachee Springs

6131 Commercial Way

Spring Hill, FL 34606

(877) GO WEEKI

www.weekiwachee.com

ACKNOWLEDGMENTS

Dedicated in memory to a friend of creative and adventurous spirit - Peter Berg (1926-2003)

The making of photographs is a purposeful and time-consuming endeavor – as is the making of a book – and the entire process involves many people we wish to thank. First to Bob Morton and to his staff at Aperture, we are ever so grateful to have had the opportunity to work with such a distinguished editor. Heartfelt thanks for believing in our vision, and seeing it through to a well-crafted book. Thanks also to Lisa Farmer and Bryonie Wise for their most able production work. We have long admired the wonderful design skills of Lawrence Wolfson, and the books he has created for colleagues. We are grateful for his keen eye for detail and for his creativity that he brought to this project. Over the years, we have read and greatly admired the writing of Lawrence Weschler and want to express gratitude for the opportunity to have had a series of insightful conversations with him. One of those talks led us to the writing of Todd Newberry, whom we wish to thank for his wonderful and thought-provoking essay. For sharing some of his bookmaking wisdom, thanks to Garrett White.

It is not possible for us to do a project like this, without the encouraging, yet critical, eye of friends and colleagues. Thanks to Niki Berg, Elisabeth Biondi, Andrew Borowiec, Martin Brading, Joan Feeney, David Feingold, Lila Garnett, Stanley Greenberg, Eric Paddock, Bruce Phillips, Sandra S. Phillips, Chris Rauchenberg, Sage Sohier, Nina Subin, David Travis, Chad Truemper and Eliot Weinberger.

To our galleries, thanks go to Kathleen Ewing and Charlotte Vasquez of Kathleen Ewing Gallery in Washington D.C.; Gail Gibson and Claudia Vernia of G. Gibson Gallery in Seattle; Alan Klotz and Janet Sirmon of Klotz/Sirmon Gallery in New York City; Paul Kopeikin of Paul Kopeikin Gallery in Los Angeles; and to David Scheinbaum and Janet Russek of Scheinbaum & Russek Ltd. in Santa Fe.

None of these photographs would have been possible without the assistance of all the aquariums in which we had the privilege to work – we are especially grateful to those on the public relations staffs. Closer to home, warmest thanks go to our assistant Alice Proujansky, who makes our life run so much smoother than it would if we were left to our own devices. Deepest appreciation to Ben and Louis Diep of Hong Color for their meticulous processing of the color film.

Finally, and perhaps most importantly, we are both blessed with families who are tremendously supportive of the vagaries of an artistic life. To our families, for years of love and encouragement – especially to our parents, Bill and Til Cook and Al and Ann Jenshel, thank you so much.

Diane Cook and Len Jenshel
New York City

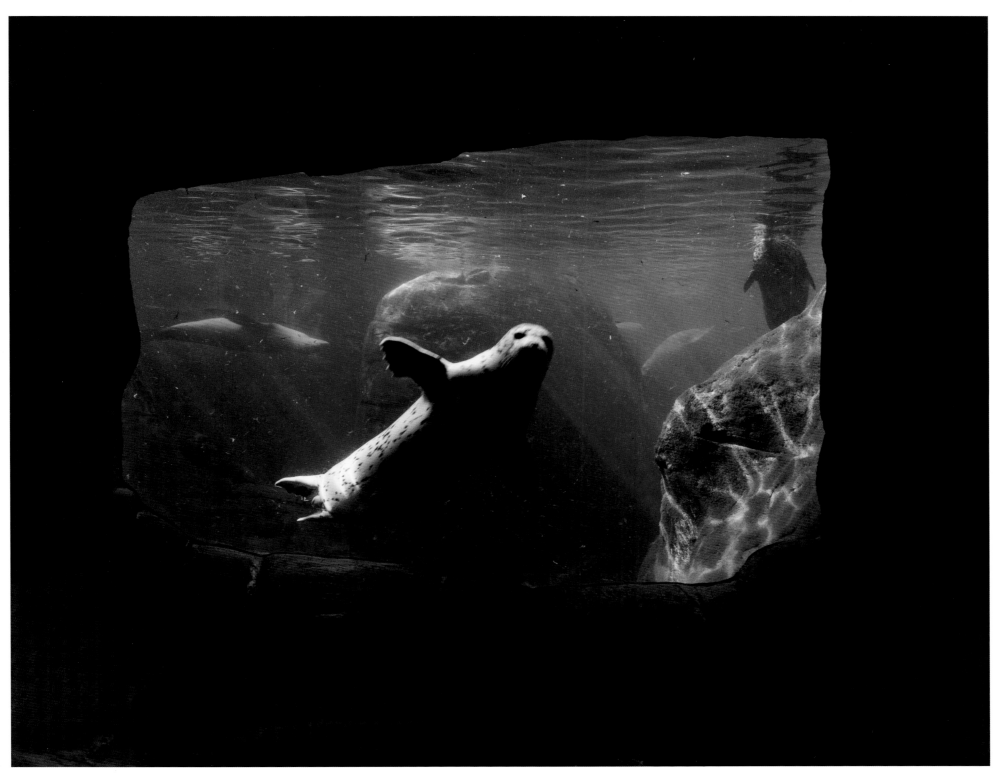

A limited-edition of one 11-by-14-inch chromogenic print of Len Jenshel's "Kaiyukan Aquarium, Osaka, Japan, 2001," signed and numbered by the artist, is available through Aperture Foundation. The edition is limited to thirty prints and four artist's proofs. For more information, visit Aperture's website.

Library of Congress Control Number:
 2003104872
Hardcover ISBN: 1-931788-21-9

Photographs courtesy: Kathleen Ewing Gallery, Washington, D.C.; G. Gibson Gallery, Seattle, WA; Klotz/Sirmon Gallery, New York, NY; Paul Kopeikin Gallery, Los Angeles, CA; and Scheinbaum & Russek Ltd., Santa Fe, NM.

Editor: Robert Morton
Designer: Lawrence Wolfson
Production: Lisa A. Farmer, Bryonie Wise

The staff for this book at Aperture Foundation includes:
Ellen S. Harris, *Executive Director*
Roy Eddey, *Director of Finance and Administration*
Lisa A. Farmer, *Production Director*
Robert Morton, *Editor-in-Chief, Books*
Andrea Smith, *Director of Publicity*
Linda Stormes, *Director of Sales and Marketing*
Alan Yamahata, *Director of Development*
Nicola Bodman, Karen Engle, Gillian Fox, Kim Phillips, Jeffrey Rogers, Fran Ula, Annie Wilker, *Work scholars*

Aperture Foundation, a not-for-profit organization, publishes *Aperture* magazine, books, and limited-edition prints of fine photography and produces photographic exhibitions worldwide. A complete catalog is available upon request.

Aperture Foundation, including
Book Center and Burden Gallery
20 East 23rd Street
New York, New York 10010

Visit Aperture's website:
www.aperture.org

Printed and bound in Hong Kong

First Edition
10 9 8 7 6 5 4 3 2 1